HORSHAM
THROUGH TIME
Susan C. Djabri

AMBERLEY PUBLISHING

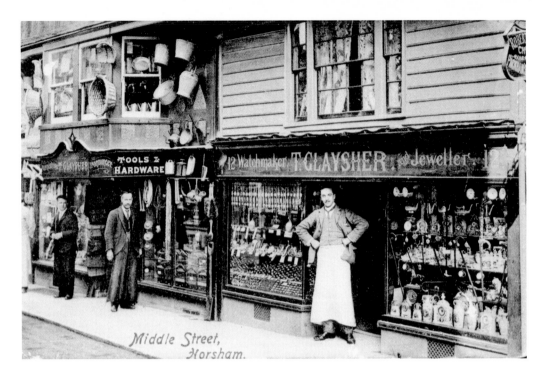

Glaysher's shops, Middle Street

Glaysher's hardware store, which can be glimpsed in the background of the photograph on page 22, and the jeweller's shop next door were typical of many small family-run businesses in Horsham that have now disappeared. The timber-framed building has survived, but not in Horsham. It was a medieval butcher's shop, which was taken down and re-erected at the Weald and Downland Museum at Singleton.

© Copyright
Editorial and text; Susan C. Djabri

Horsham Museum photographs; Horsham District Council and Horsham Museum Society

1951, 2000 and 2009 colour photographs; Horsham Photographic Society
1960s photographs; Roger Baker ARPS

Other copyrights; see acknowledgements

First published 2009

Amberley Publishing Plc
Cirencester Road, Chalford,
Stroud, Gloucestershire, GL6 8PE

www.amberley-books.com

Copyright © Susan C. Djabri, 2009

The right of Susan C. Djabri to be identified as the Author of this work has been asserted in accordance with the Copyrights, Designs and Patents Act 1988.

ISBN 978 1 84868 534 5

British Library Cataloguing in Publication Data.
A catalogue record for this book is available from the British Library.

Typeset in 9.5pt on 12pt Celeste.
Typesetting by Amberley Publishing.
Printed in the UK.

Introduction

'This is a very nice, solid country town', said William Cobbett when he visited Horsham on one of his *Rural Rides* in 1821, 'very clean, as all the towns in Sussex are'. 'An exasperating, traffic-laden, half-realised town', said Ian Nairn and Nikolaus Pevsner of Horsham when writing the Sussex volume in the great *Buildings of England* series in 1965. In 1990 Horsham was said to be the top 'boom town' in Britain and it has since been listed as one of the best places in the country to live. So what has happened? How can Horsham have provoked such conflicting opinions at different times and what circumstances have brought these about?

During the last century Horsham was faced with the need to find a new rôle after its traditional function as a market town was rendered obsolete. If it were not to become little more than a rural backwater or a suburb of the new town of Crawley, it had to modernise and find a new economic base. Nairn and Pevsner saw Horsham at a particularly low ebb — when it had not yet come to terms with the realities of its situation — but change was already in the air. The establishment in Horsham of the British headquarters of the Swiss pharmaceutical company, CIBA-Geigy (now Novartis), and the Sun Alliance insurance company (now Royal Sun Alliance) opened up new prospects and job opportunities, as did the expansion of nearby Gatwick airport. The population has trebled in size in the last century and the town itself now stretches right across the old Horsham Common to the northern bypass.

Growing prosperity made it possible for Horsham to expand and modernise, though the changes needed sometimes provoked great and painful controversy. At the end of an unprecedented period of change and renewal, through traffic has been channelled into a dual carriageway that encircles the historic heart of the town, and a well-planned and sometimes imaginative redevelopment of important parts of the town centre has taken place, in which Horsham District Council has worked closely with major retailers prepared to invest in the town's development. The pedestrianisation of the Carfax, with the creation of the Lynd Cross square around the Shelley fountain and the new Forum, has given Horsham the public spaces that Nairn and Pevsner said were needed. An increased awareness of the town's long history has led to

the preservation of many fine old buildings, often by conversion to new uses, for which the town has received a Civic Trust award. It is, once again, a very nice, solid country town but now it is much better prepared to face the challenges of the twenty-first century.

It would not have been possible to produce this book without the great support that I have received from Roger Baker ARPS, the chairman of Horsham Photographic Society, and his colleagues Martin Woolger and Anne and Peter Kingham, who have taken the new colour photographs. By a happy coincidence, the Photographic Society is celebrating its sixtieth anniversary this year, under the caption '60 Years in a Flash', so it is a good opportunity to showcase the talents of its members. The society has already undertaken two major photographic surveys of the town, in the years 1951 and 2000. The photographs that members took on these occasions, some of which are also used in this book, have been deposited in Horsham Museum as a valuable record of the past for future generations. Jeremy Knight, the curator of Horsham Museum, has also given staunch support and advice as regards the use of the photographs and pictures from the museum's collections, which are the other essential component of this book. A guide to further reading on the history of the town can be found on Horsham Museum's website: www.horshammuseum.org.

In the book itself, we have tried to take the reader on a tour of the town through time as well as space. We start from the river and the thirteenth-century church and explore the medieval streets in the town centre before moving further out, in various directions, to other places of interest. We have attempted to show developments in Horsham 'through time', rather than just 'then and now', and this has sometimes involved devoting more than two photographs to a particular subject. In writing the captions I have tried to sketch in a little of the historical background, but in most cases it is the pictures themselves that tell the real story.

Susan C. Djabri

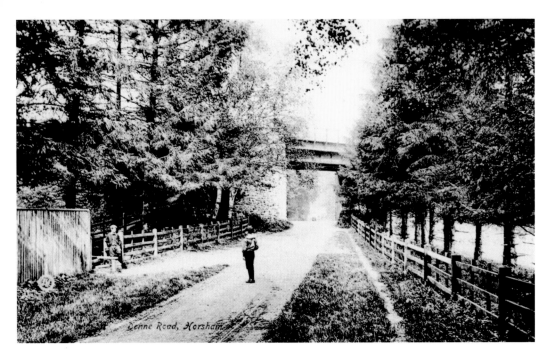

Denne Road looking south

The railway bridge marks a significant spot where the road crosses the River Arun, later crossed by the railway to the South Coast. This is thought to be very near the site of the first ford or bridge across the river, which gave rise to the original settlement, in a forest clearing, sheltered by Denne Hill. Horses were later bred here, giving Horsham its Saxon name 'Horse-ham' meaning the 'place of horses'.

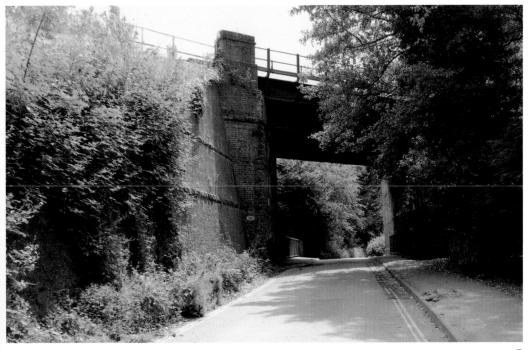

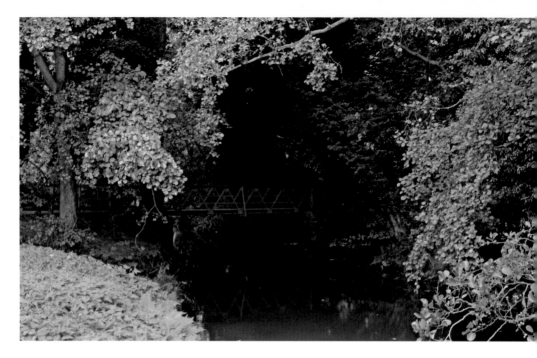

The River Arun footbridge

This footbridge over the River Arun, south of St Mary's church and now almost hidden by undergrowth, leads to the cricket ground and a path up Denne Hill. The riverbank was the place where many Horsham people sought relaxation before better facilities became available in Horsham Park. The diarist, John Baker, frequently enjoyed his 'old walk to the mill' in the 1770s, and a muddy public swimming pool existed beside the millpond of the town mill in the early 1900s.

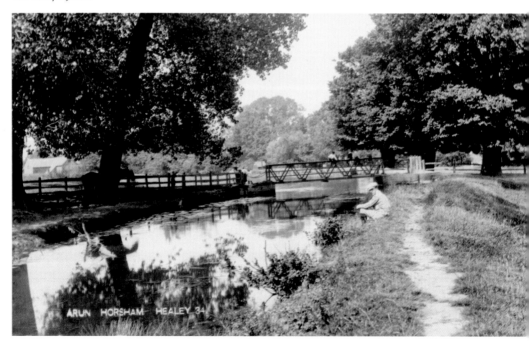

ARUN HORSHAM HEALEY 34

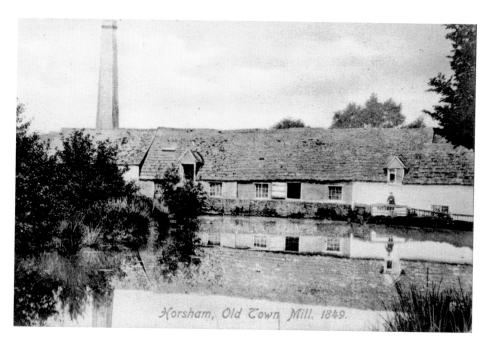

Horsham, Old Town Mill. 1849.

The Old Town Mill, Mill Bay Lane

A watermill on the River Arun was first mentioned in Horsham in the thirteenth century, and a 1734 map of the Manor of Hewells shows a mill on this site. John Smart and his son-in-law, Stringer Sheppard, were millers from 1751 onwards, and Stringer's son, William Sheppard, was still operating the mill in 1849. The mill was later rebuilt and taken over by William Prewett. It produced animal feed (provender) until the 1970s, before being converted into an office building.

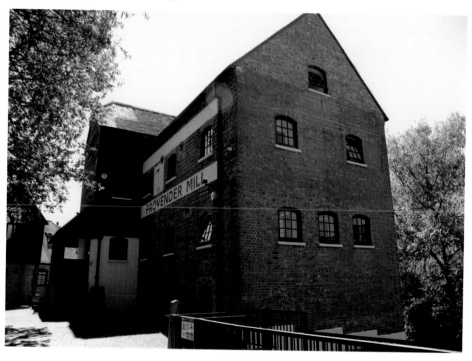

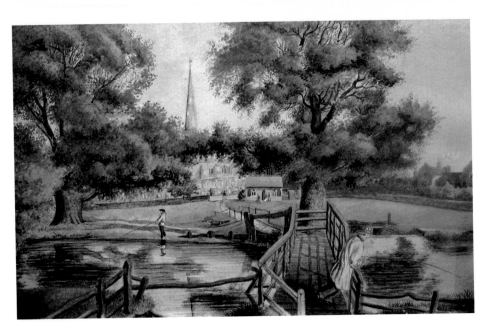

The spire of St Mary's Church

St Mary's Church spire, as seen from the river, has long been a popular subject for artists and photographers. The early painting, by an unknown artist, can probably be dated to the 1840s, as Collyer's School on the right has been rebuilt. At this time the footbridge had a three-barred gate at the end, and people came here to fish. The photograph by Edgar Bastard, probably taken in the 1920s, features the spire's reflection in the clear, still river.

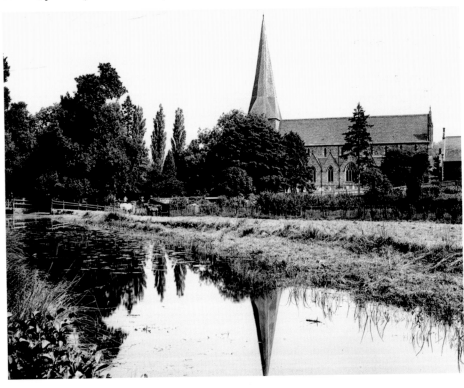

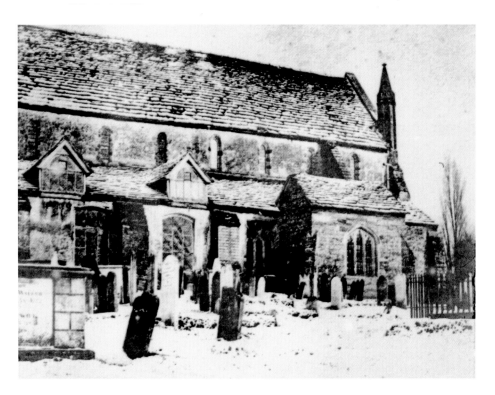

St Mary's Church seen from the south

Young Henry Padwick, an enthusiastic amateur photographer, took a valuable series of photographs of St Mary's Church in the early 1860s before its extensive restoration in 1864-5. The chapel with the triple lancet window on the far right, which appears to be standing alone in the early photograph, is now part of the rebuilt south aisle. The newly built Parish Room is a striking modern addition to the ancient thirteenth-century church.

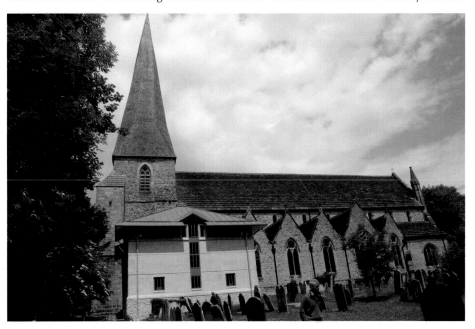

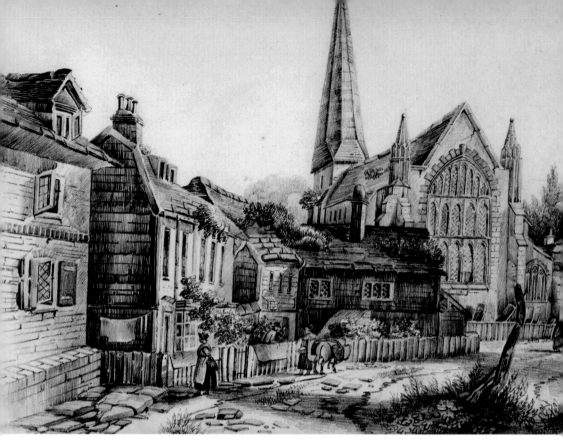

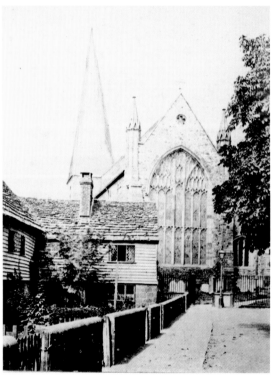

St Mary's Church and the Priests' House from Normandy

This drawing of St Mary's Church, which shows the medieval Priests' House and the parish workhouse on the left, takes us back to the time before photography. It shows the church and the cottages in a very poor state of repair, with cracks in the church and grass growing on the roofs, at a time of great rural poverty in the 1830s. The rare photograph of the Priests' House was probably taken shortly before it was pulled down in 1895.

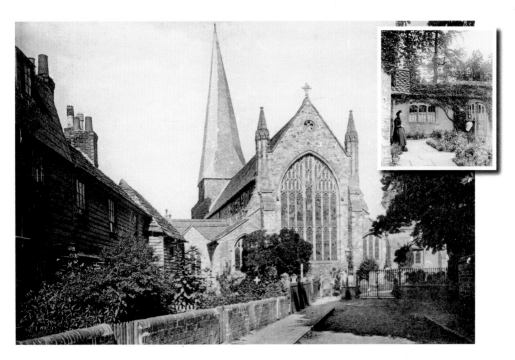

St Mary's Church and the almshouses in Normandy, looking west

St Mary's Almshouses were established in the old parish workhouse in Normandy in 1844, after the new Union Workhouse was built in Crawley Road. Originally the occupants were restricted to spinsters or widows of the parish but later a few married couples were also admitted. The almshouses were rebuilt later in the nineteenth century (see inset) and then rebuilt again in the 1950s. The earlier photograph shows the first rebuild and the colour photograph the almshouses as they are today.

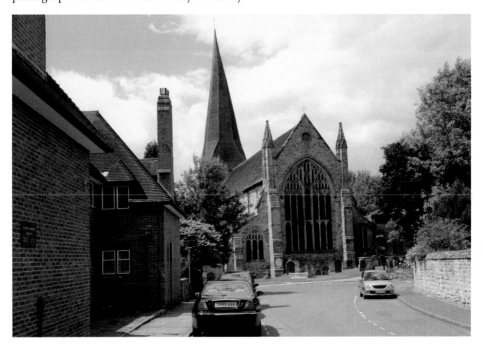

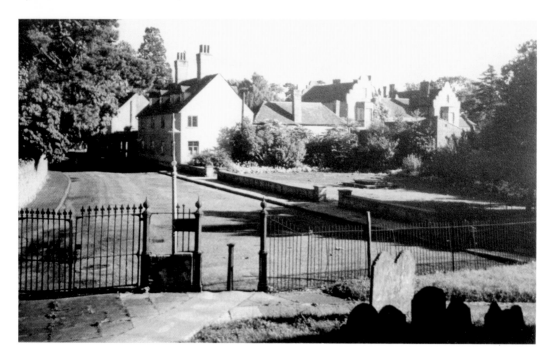

The almshouses in Normandy, looking east

This 1951 photograph captures the moment when the old almshouses had been razed to the ground before rebuilding, revealing the back of the former Collyer's School, then Denne Road Girls' School and soon to be pulled down. Collyer's School was built here in 1541 with money left by Richard Collyer, a wealthy London mercer born in Horsham, and rebuilt on the same site in 1840. Originally a highly regarded grammar school, it only provided elementary education in the nineteenth century.

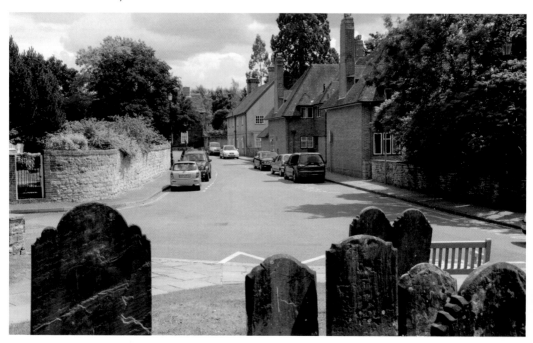

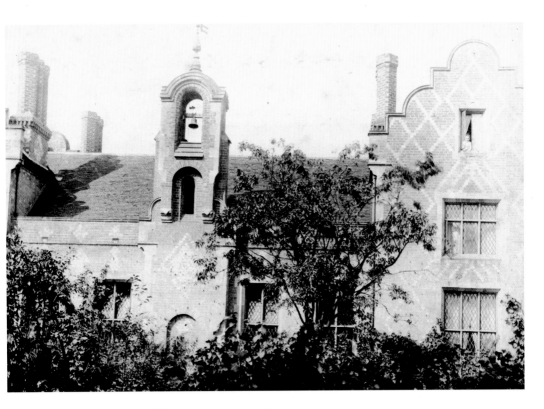

Schools in Denne Road

The presence of a small child at the top window of the Usher's House suggests that this photograph of Collyer's School was taken when Richard Cragg was acting headmaster (1869-1883) and the younger James Williams was his usher, or second master. A new Collyer's School was built in Hurst Road in 1893. The foundation stone of St Mary's Primary School, built on the same site but further away from Denne Road, was laid by the Queen Mother in March 1965.

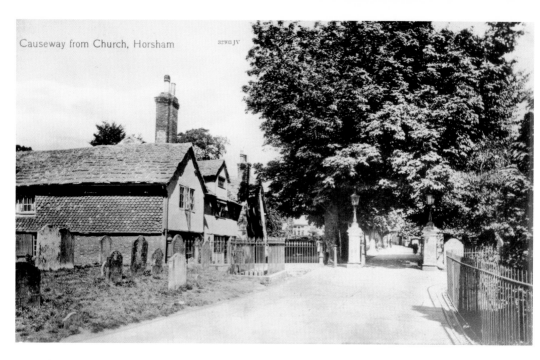

Causeway from Church, Horsham

View from the churchyard looking north up The Causeway

The iron railings have gone, but little else has changed between these two photographs. Beside the path is the grave of Helena Bennett, the anglicised name of a Moslem lady of Persian origin, Noor Baksh, married in India to General Benoît de Boigne, who later abandoned her. The grave does not face Mecca, as once thought — it was the last available space in the churchyard. Helena, a Christian convert, lived in St Leonard's Forest and died in December 1853.

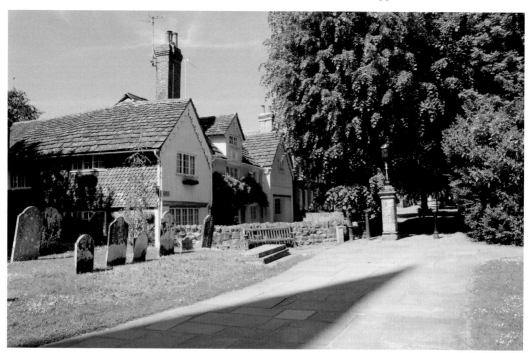

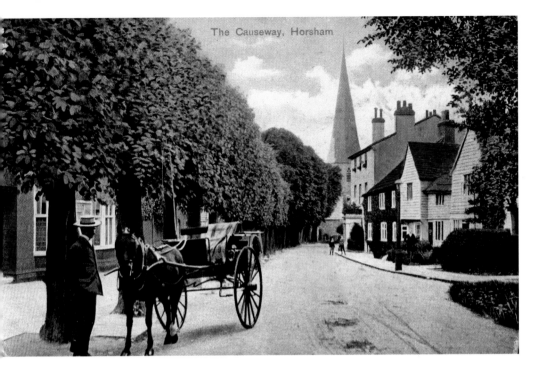

The Causeway looking south towards St Mary's Church

This view down The Causeway is one of Horsham's most cherished scenes and every effort has been made to preserve it unchanged during the last century. The earlier photograph, taken about 1906, was one of the first to appear as a coloured postcard. The Causeway possesses a great number of medieval timber-framed buildings and, although some of these have later been refaced in differing styles, the general effect is remarkably harmonious.

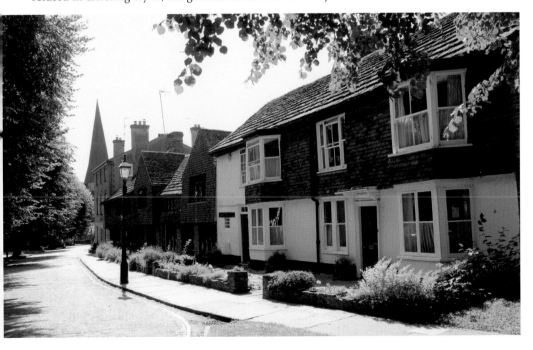

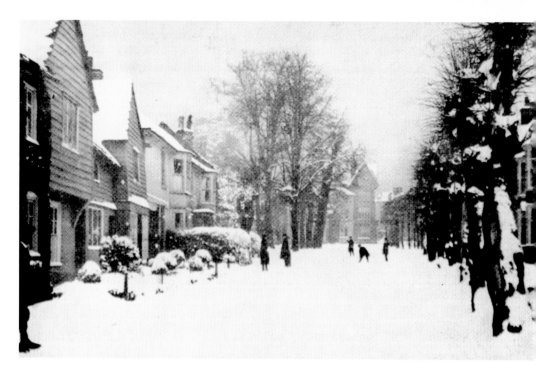

The Causeway looking north

The photograph of the top of The Causeway in heavy snow in the 1890s, when there were several severe winters, is contrasted with a contemporary summer view. It is known that lime trees have been planted down this street since the eighteenth century, as they are shown on a 1770 map. They were noted with approval by John Evans, a visitor to the town in 1814, who said that he was 'struck with the town's appearance'.

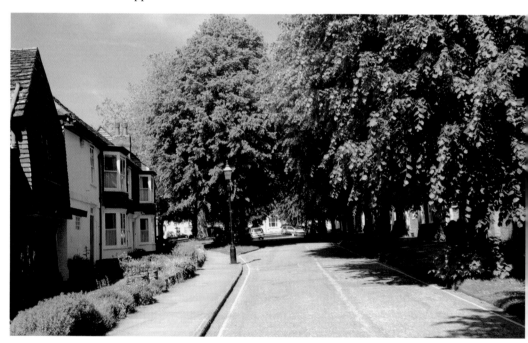

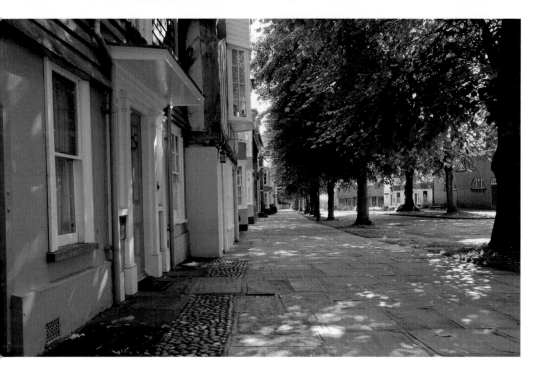

The Causeway looking south

These rather more impressionistic views of The Causeway, with their patterns of dappled light and shade, give some idea of its special quality and help to explain why it has been called 'the most beautiful street in Britain'. The earlier photograph was taken in 1951, when the trees lining the east side of the street were far smaller than they are now.

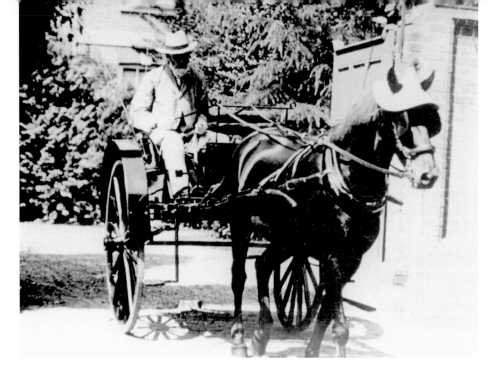

Manor House, west side of The Causeway

The Manor House was built in 1705 by Nathaniel Tredcroft but by the end of the nineteenth century it was owned by Henry Padwick, here seen driving out of the gates behind a horse wearing a sun hat! It later became a school and then the national headquarters of the RSPCA. After the RSPCA moved to a new building in Southwater in 2002, the Manor House became part of a carefully planned residential development.

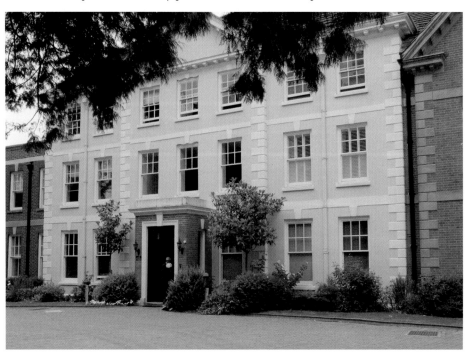

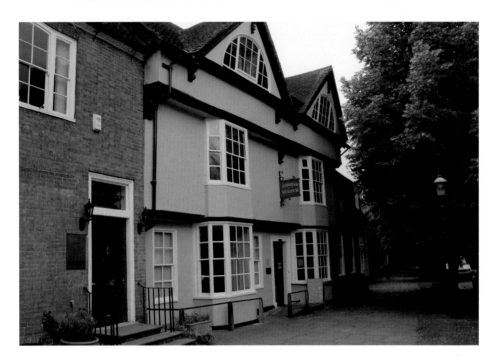

Causeway House, east side of The Causeway

Causeway House, one of Horsham's finest Elizabethan townhouses, became the permanent home of Horsham Museum in 1947. Its collections range from local dinosaur fossils to the architect's model for the new Pirie's Place shopping centre. The lower photograph shows one of its prized exhibits, a rebuilt 'pentacycle' (the quirky invention of a Horsham architect, Edward Burstow, which was used by the post office for delivering mail in the 1880s), on display outside the museum in a reconstruction of its use.

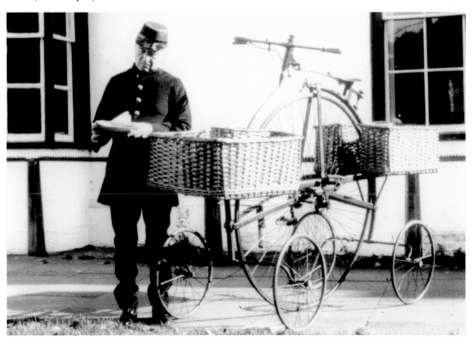

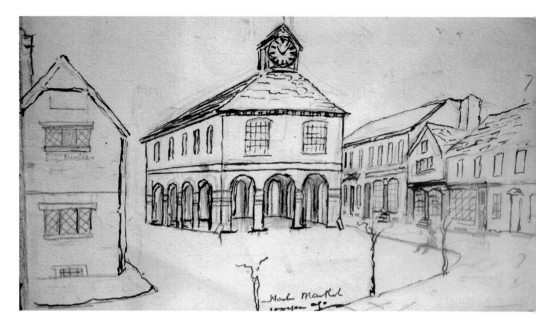

Market House (now Town Hall) in Market Square

This drawing by George Mann of the original Market House was based on a sketch made before 1808 when it was rebuilt by the Duke of Norfolk as a town hall. It is currently used as the town's Registry Office, as shown by the wedding car in the modern photograph. The house on the right is where a tailor's daughter, Sarah Hurst, lived and wrote about the life of the town in her diaries, from 1759 to 1762.

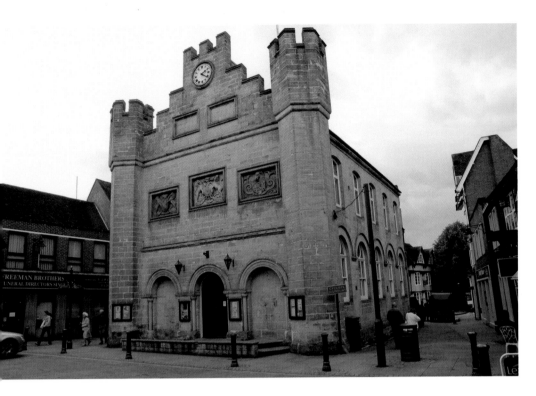

Town Hall, Market Square

The castellated northern end of the town hall bears the Royal coat of arms, the arms of the Duke of Norfolk (as Lord of the Manor of Horsham) and the arms of the Borough of Horsham, fancifully supported by dragons' tails and surmounted by a horse's head. The earlier photograph, probably taken about 1903, shows the recently built Anchor Hotel on the left, with a sign for Cramp's Temperance Hotel further down and the old Bear Inn on the right.

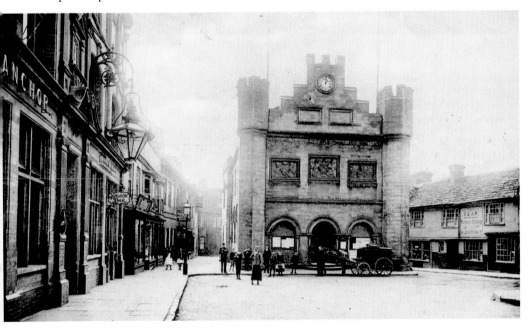

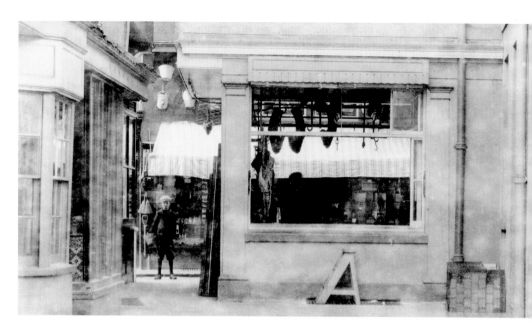

North-west corner of Market Square, looking through to Middle Street

This corner of Market Square looked rather different in the early 1900s, as Sendall's butchers shop had windows on both sides, and there was a view through the alley to Glaysher's shop, hung with baskets. Middle Street was formerly known as 'Butcher's Row', but there were also butchers in Market Square. The building in the foreground previously belonged to the Philip Chasemore, who grew rich from supplying meat to the Horsham military barracks during the Napoleonic Wars.

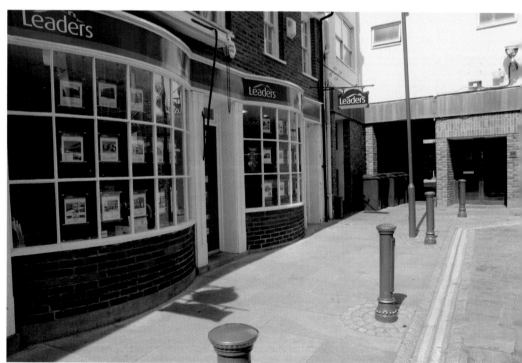

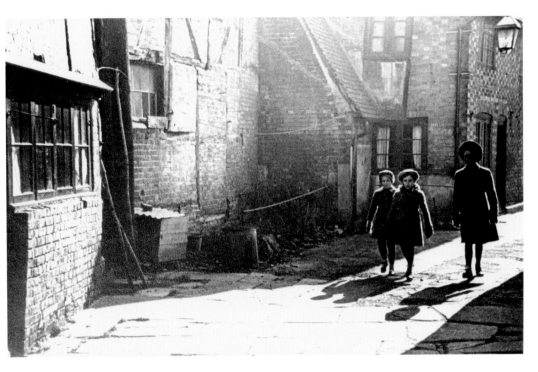

Pump Alley, off Market Square, leading to Talbot Lane
When this striking photograph of three young girls walking through Pump Alley was exhibited at Horsham Museum in 2001, it was not known who they were or when the picture was taken. Luckily Mary Langridge (formerly Lintott) saw the photograph, in which she was the central figure, and said it was taken in 1942. Her companions were Gillian and Joy Dinnage, sisters from Dover, who had been sent to live with their grandparents in Horsham during the war.

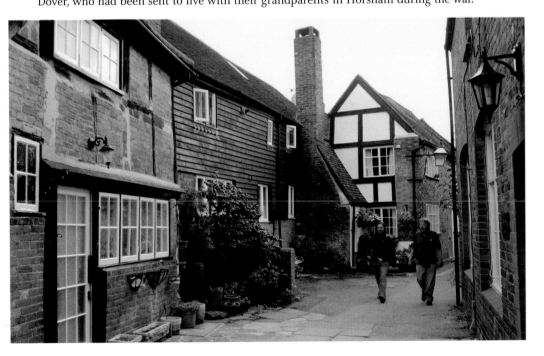

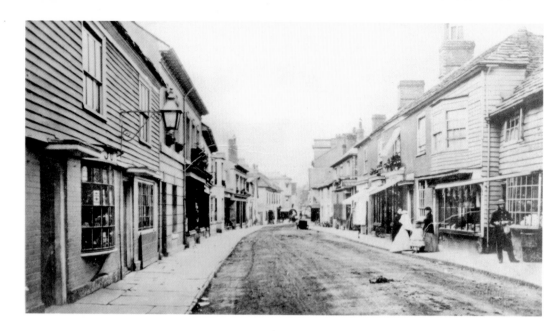

East Street, south side, looking west

This is one of the earliest known photographs of East Street, taken in the 1850s when the street was still a mixture of shops and private houses. Some of the old buildings still remain today, with the addition of new shopfronts, but others have been rebuilt. East Street suffered a decline in importance in the last fifty years, but it is now being revitalised with the opening of several smart new shops and restaurants.

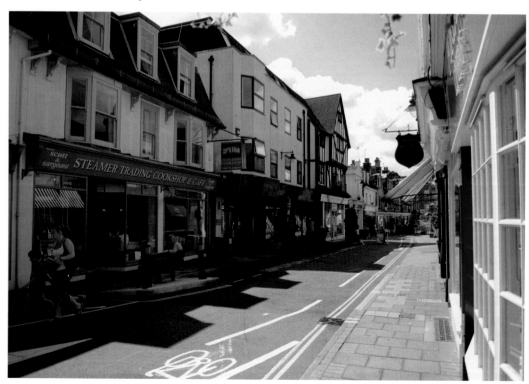

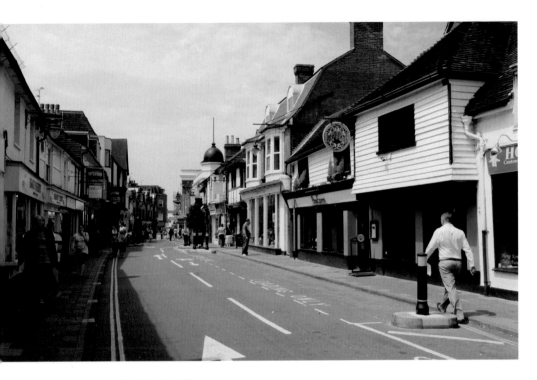

East Street, north side, looking west

The weather-boarded building in the foreground is medieval in origin, and remarkably little changed today from the earlier photograph, taken about 1906. The little cupola on what was the Co-operative building is a more recent addition to the street scene. East Street is now closed to through traffic during the main part of the day, so it appears less busy, but the absence of cars makes it a safer and more pleasant environment for pedestrians and cyclists.

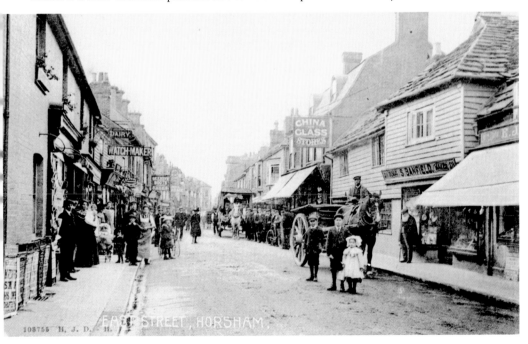

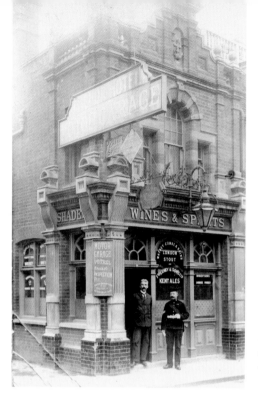

East Street, Anchor Bar

Part of the Anchor Hotel in Market Square, built in 1897 in place of the Anchor Inn, is the Anchor Shades Bar, here seen with its manager standing on the doorstep. Above his head is a large sign for the hotel garage, which was probably one of the first in Horsham. It was sited in the old coaching inn's stable yard, which opened on to East Street. Today this decorative little corner building houses an information centre for young people.

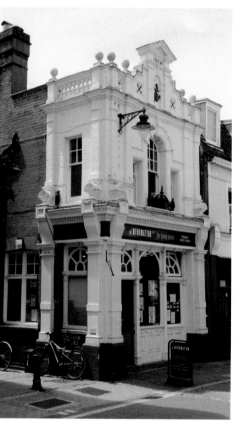

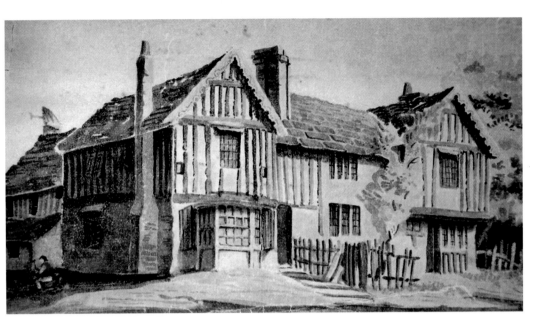

Corner of East Street and Denne Road, looking east

One of Horsham's finest medieval burgage houses, known as Bishop's, stands on this corner, now divided into a newsagent's shop and a restaurant. The painting of the building, by Maria Hurst, dates from the 1830s and is the earliest known depiction of the house. Today only half of the original Horsham stone roof remains, and only one wing end retains its close boarding, but the building is still an important feature of the town's landscape.

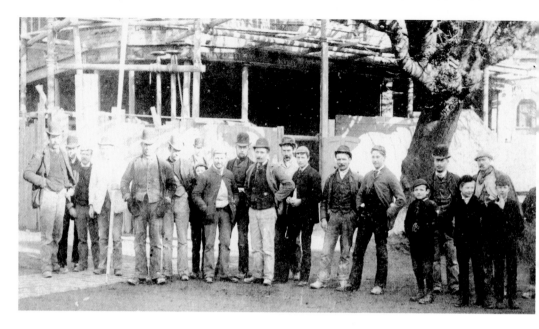

Corner of East Street and Park Place, formerly Park Street, looking east

Another fine burgage house called Ashley's stood on this corner, but it was pulled down in the early 1900s and work began on a new building. The earlier photograph shows the rather primitive scaffolding of those days and the workforce apparently taking a break. Park Street has now largely disappeared under Parkway, part of the new ring road, and Park Place is just a short cul-de-sac leading to Pirie's Place multi-storey car park.

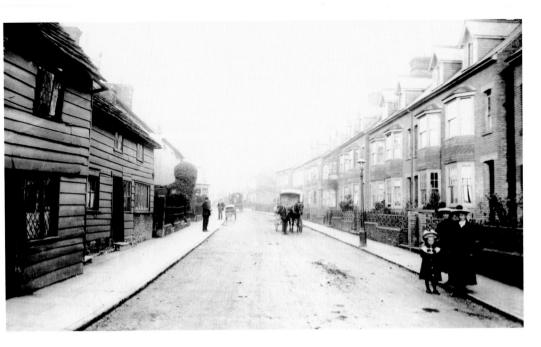

Park Street, now crossed by Parkway, looking north towards North Street

Park Street was formerly a quiet and largely residential street to the north of Denne Road, which probably lay along the earliest North-South route through Horsham, leading directly to the river crossing. The earlier photo shows some old cottages on the left which have now disappeared. Some of the terraced houses at the north end of the road still survive near what is now a major traffic junction, spanned by the Royal Sun Alliance 'campus' built in the late 1980s.

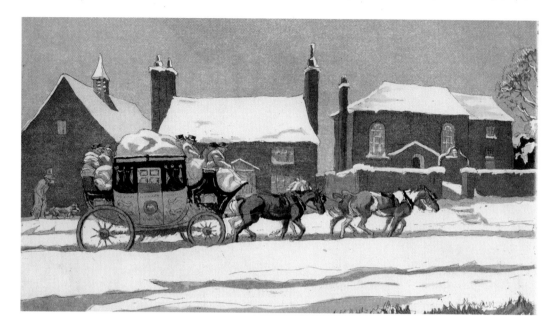

Coaching days in Horsham

Horsham was an important stage-coaching centre in the early nineteenth century, with coaches passing through the town to and from London, Brighton, Worthing, Guildford and Oxford. Dr Geoffrey Sparrow, a local artist whose works enliven the walls of Horsham Museum, here depicts 'The Accommodation' coach in 1812, passing the Quaker Meeting House in Worthing Road. The photograph shows a coach built by John Heath's coach factory in Springfield Road, with saddlery by William Albery of West Street.

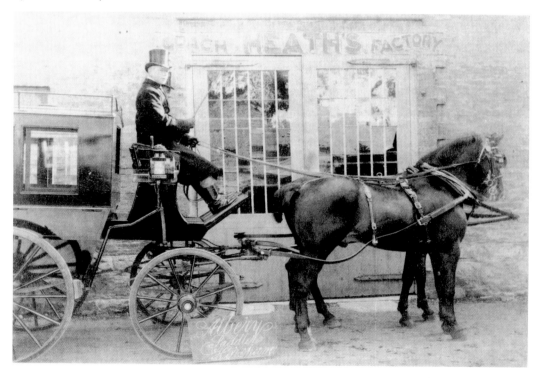

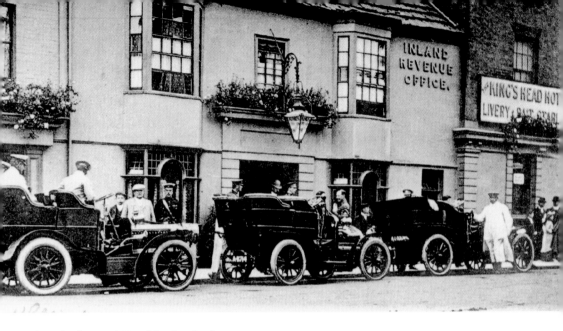

The King's Head Hotel in the Carfax

The King's Head was Horsham's premier coaching inn in the eighteenth and nineteenth centuries but here it is seen entering the motor age while still advertising its livery stables. The 1907 photograph shows three open-top 40/50 model Rolls Royces, described as 'the best car in the world', outside the hotel. They were said to belong to a visiting German prince, seen here with his military entourage. The later photograph, taken in 2000, shows the hotel before it closed down.

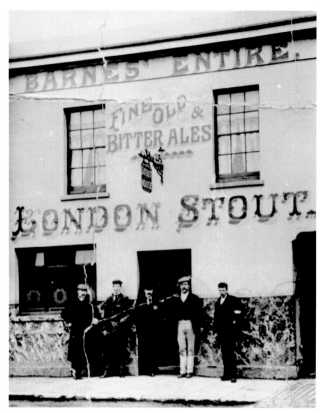

Carfax, east side

The Stout House has been in business in the Carfax for well over 100 years — it sold Thornton's beers before being taken over by G. H. Barnes and Co., who went into partnership with a local maltster, King and Sons, in 1906 to set up the much-loved King and Barnes brewery. Next door can be seen the façade of the former Electric Cinema, later known as the Theatre Royal, where Michael Caine first performed as a professional actor in the early 1950s.

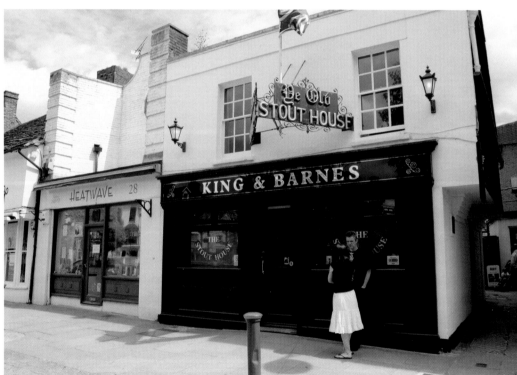

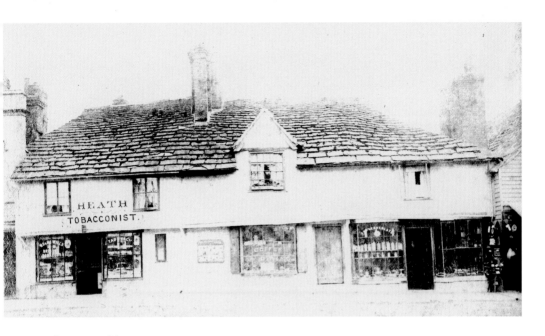

Carfax, east side

This medieval timber-framed building with its fine Horsham stone roof has changed very little during the last century. It is one of the buildings on The Chequer burgage site, which lay along the east side of the Carfax. Samuel Bryan, a master baker, ran it as an inn in the seventeenth century, and had his bake-house there. He also served as the gaoler at the county gaol, then on the north side of the Carfax, from 1668 to 1686.

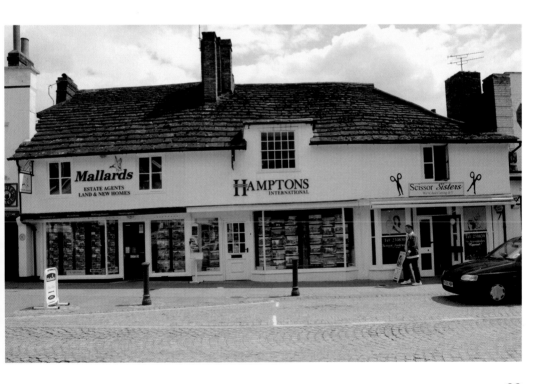

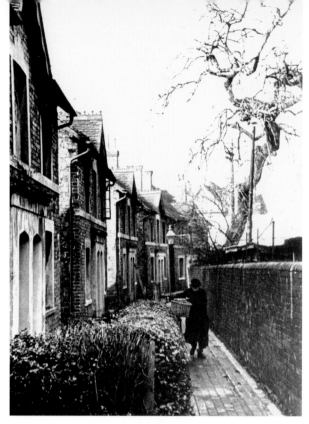

Pirie's Place, off the Carfax

Pirie's Place was originally a row of fourteen Victorian cottages along a narrow path or 'twitten' off the Carfax. They were built by William Pirie, the headmaster of Collyer's School from 1822 to 1868, as a source of income for his retirement, and bore a thistle to mark his Scottish origins. The cottages were replaced in 1990 by a courtyard shopping centre, which has the thistle motif at its main entrance. The statue of William Pirie in his familiar donkey cart, by Lorne McKean, has become a much-loved feature. Children can climb into the cart and sit beside him.

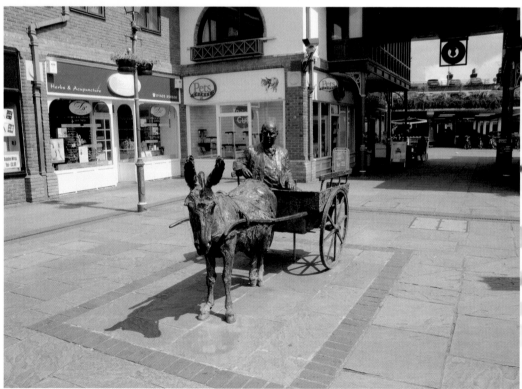

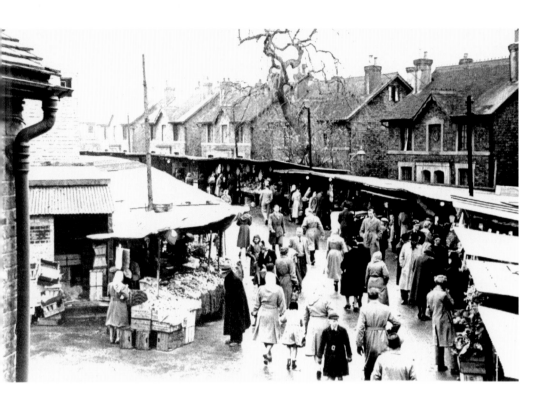

Pirie's Place shopping centre

William Pirie's cottages overlooked the Central Market, seen here in 1951, which has been replaced by a Waitrose supermarket to the left of the contemporary photograph. The light and airy wrought iron and glass canopy over the pavement café echoes the Victorian style of the original cottages and protects Pirie's Place customers more effectively than the canvas awnings of the former market stalls.

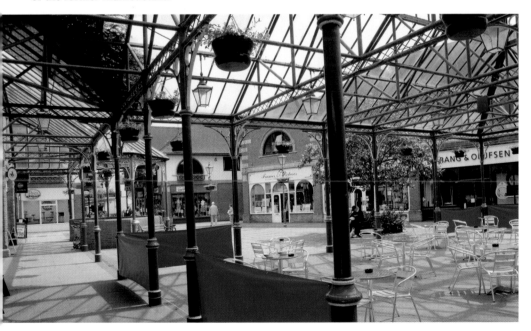

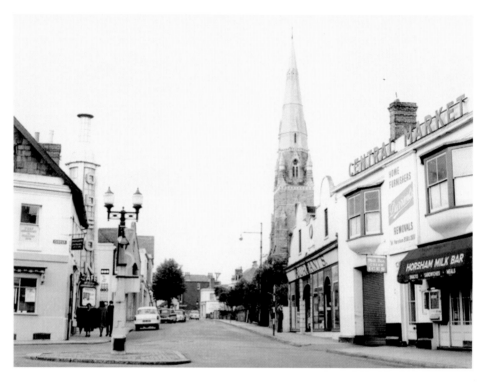

North Street from the Carfax

The 1960s photograph shows the Art Deco 'lighthouse' outside the Odeon Cinema on the left and St Mark's Church spire towering above all the other buildings. Today, the spire remains, but the rest of the church has been demolished and the buildings of the Royal Sun Alliance 'campus' hem it in closely. Behind the tree are steps lead up to Chart Way, the pedestrian bridge that follows the line of this former part of North Street as it spans Albion Way.

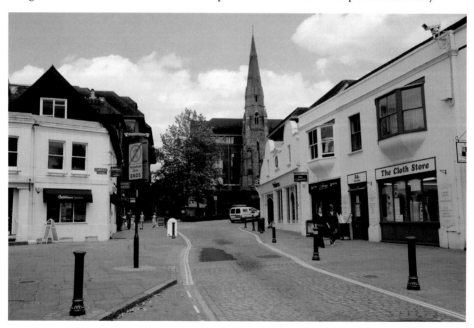

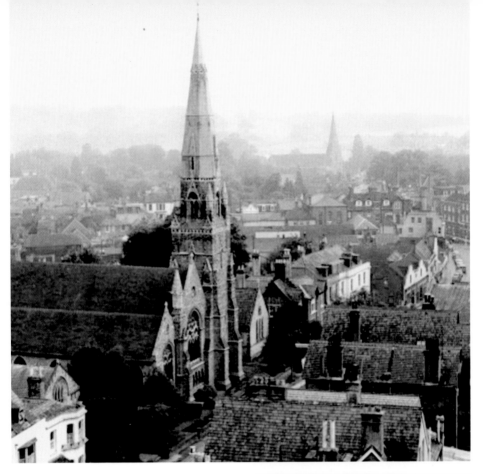

St Mark's Church

This fine view of the former St Mark's Church was taken in the 1960s, when the church, built in French Gothic style, was no longer used. St Mark's was originally built in 1840 as a chapel of ease for St Mary's Church and was later extended to accommodate the growing population. By the 1930s, more people were living outside the town centre as the town expanded, so the congregation of St Mark's decreased and it was closed. The photograph was taken from the top of Stocklund House, a ten-storey skyscraper that had been recently built. The roofs of the large houses in North Street can be seen in the foreground, with the Carfax in the middle distance and St Mary's Church spire in the background, silhouetted against the surrounding hills. A new and strikingly modern St Mark's Church has now been built in North Heath Lane, where it serves the growing new community of North Horsham, which has expanded tremendously in the last thirty years.

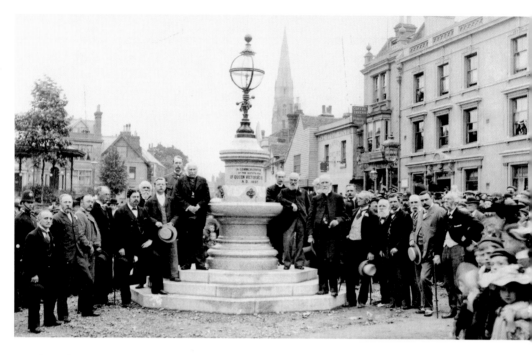

Drinking fountain

The drinking fountain placed in the Carfax in 1897 to celebrate the sixtieth year of Queen Victoria's reign was relocated to Copnall Way in 1977 and then to the northern end of Chart Way in 1993. The fountain is seen with all the Horsham dignitaries who were present at its dedication in the earlier photograph. Today it is seen in its new location outside the restored burgage house called 'The George or Bottings', on the right, with the Black Jug public house in North Street in the background.

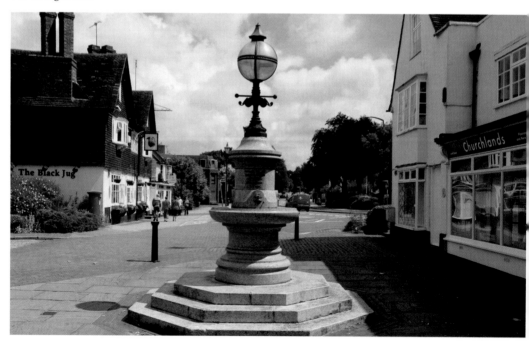

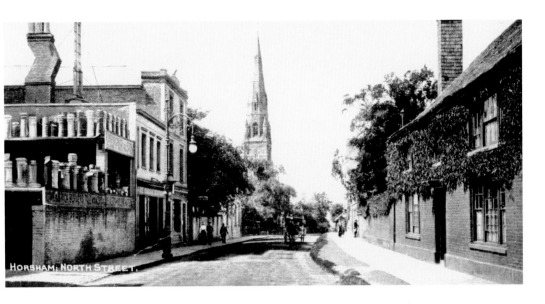

North Street/Chart Way

The earlier photograph shows the part of North Street, which has now disappeared, with the house of Dr J. C. Padwick, a son of Henry Padwick of the Manor House, on the right. The photograph of Chart Way, which has replaced this part of North Street, shows The George on the far left and the new buildings of the Royal and Sun Alliance 'campus', leading up to the big glass-fronted building that spans Albion Way.

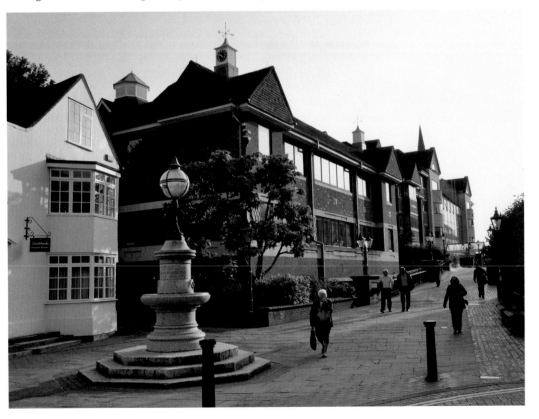

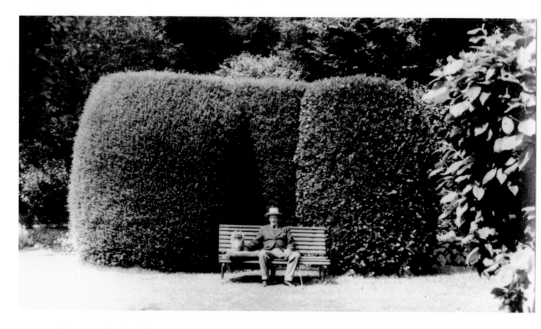

29 North Street/Parkside House

Where Dr Padwick once sat alone in his secluded garden, after his retirement from medical practice, Parkside House was built as the main headquarters of the Royal Sun Alliance insurance company in the 1990s. It has now been sold to West Sussex County Council and is to become their offices for the northern part of the county. Parkside House replaced the earlier skyscraper, Stocklund House, which was demolished in April 1992.

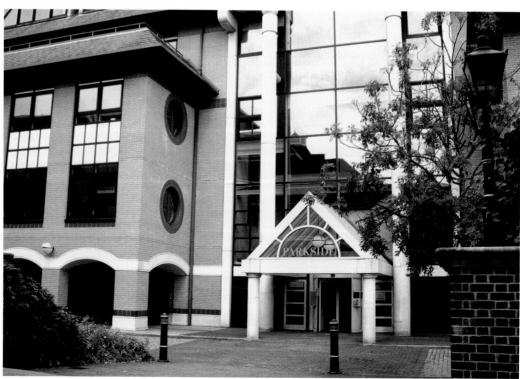

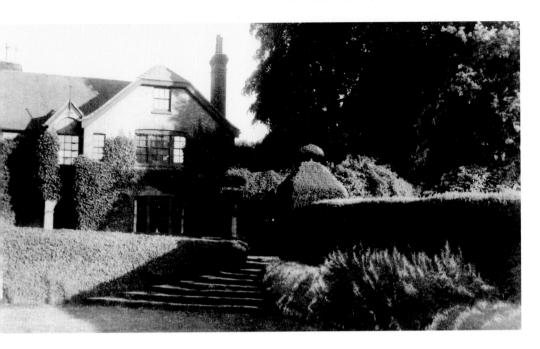

North Street/Chart Way

This and the previous photograph of Dr Padwick's house and garden are eloquent reminders of the privileged lifestyle enjoyed by the professional men who lived in this part of North Street before the Second World War. Now the bold and imaginative glass-walled Royal Sun Alliance building, spanning Albion Way, brings a very modern aspect to this part of Horsham. It houses a huge Venetian chandelier that looks spectacular when lit at night.

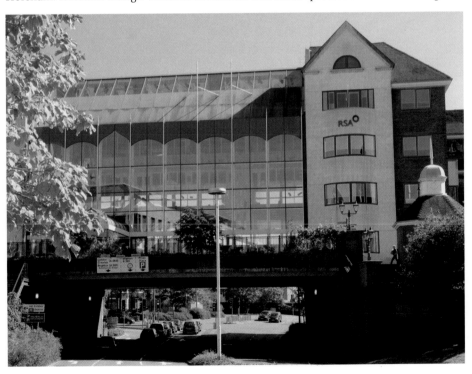

Carfax Island, north-east corner

The photograph of the cottage that stood on the north-east corner of the island in the centre of the Carfax shows us how it looked before the Bank Buildings, designed by the London architect Frederick Wheeler, were built there in 1897. The bandstand on the right was first put up in 1892, a few feet away from its present position. It is seen here decorated for the Britain in Bloom competition, in which Horsham won a gold medal in 2007 and 2009.

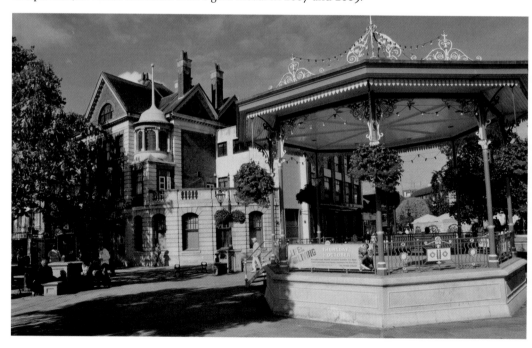

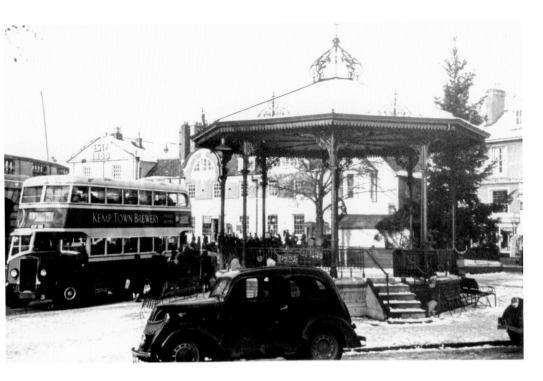

Carfax looking north

This view of the Carfax in 1951 shows something of the traffic problem of that time, with cars and buses converging from different sides of the bandstand into one narrow main road through the town centre. Now the north side of the Carfax is a pedestrianised area and the bandstand can become the centrepiece of the Christmas decorations. Traffic is now restricted to one direction through the Carfax, and Albion Way handles the main flow of traffic through the town.

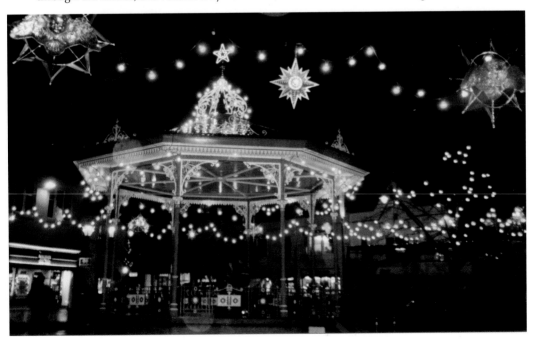

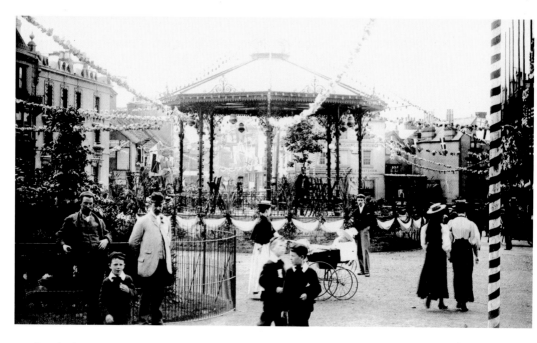

Carfax, looking south

The earlier photograph was taken in 1897 by the professional photographer, John Hicks, whose Carfax Studio was situated nearby. It was originally thought that the decorations were put up to mark Queen Victoria's Diamond Jubilee, but they were not in evidence when the drinking fountain was unveiled and it is now thought that they were put up to mark the Battle of Flowers, held in August 1897. The Carfax is still a place where Horsham people gather to be entertained.

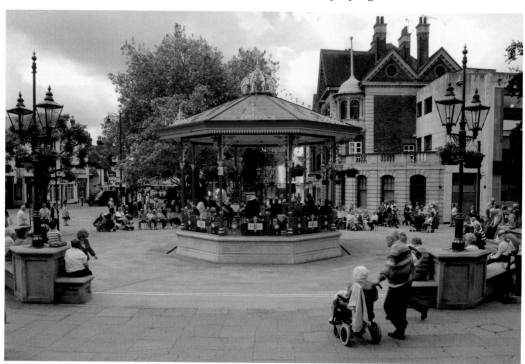

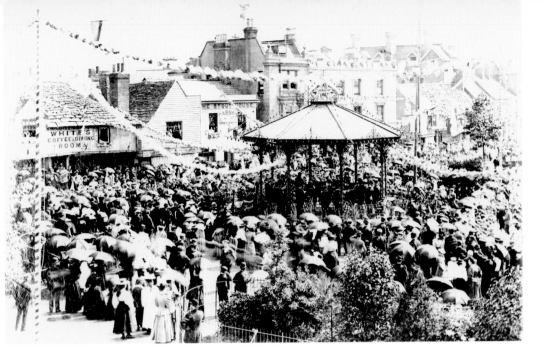

Carfax band concert

Leaning out of his studio window in Richmond Terrace, John Hicks photographed a band concert taking place in the Carfax on a rainy day during the 1897 festivities, judging by the number of umbrellas held aloft. The spectators in June 2009 enjoyed a much sunnier afternoon when listening to a jazz band concert. The bandstand was restored after a campaign to raise money in 1978, and it was repainted in its original colours after the design was found in Horsham Museum archives in 1992.

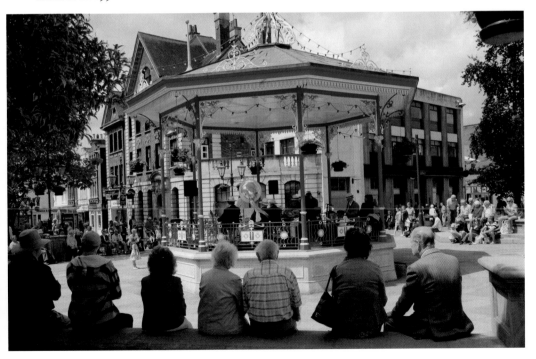

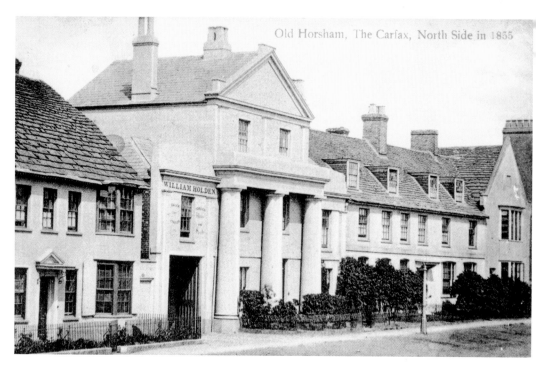

Carfax, north side

The 1855 photograph was taken by Thomas Honywood, who is thought to have been the town's first amateur photographer. It shows the Fountain and Cock brewery, then owned by William Holden, and Grandford House, on the site of the old gaol, as the home of the businessman, Henry Michell. The later photograph shows the modern buildings that replaced them in the 1960s, but the old house in the foreground has survived until today as a lawyer's office.

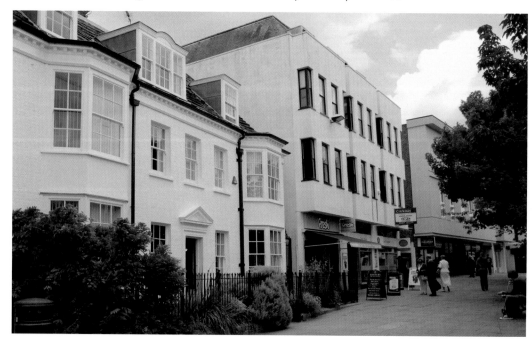

Carfax War Memorial

The Horsham War Memorial, surrounded by a wall on which the names of Horsham men who died in the two World Wars are recorded, was moved from the east side of the Carfax to the newly pedestrianised area, shortly before the annual Remembrance Day service was photographed here by Ray Luff in 1992. Five bronze roundels, sculpted by Edwin Russell as a celebration of life and natural beauty in all its forms, were placed on the back wall in 1993.

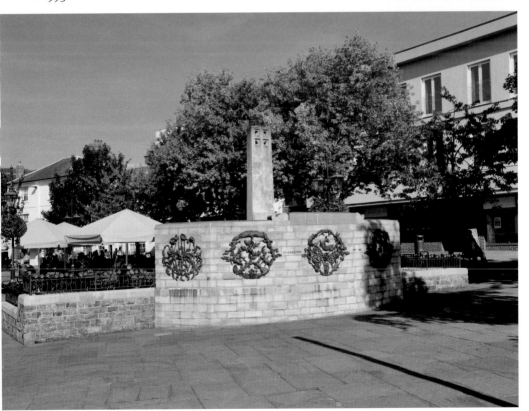

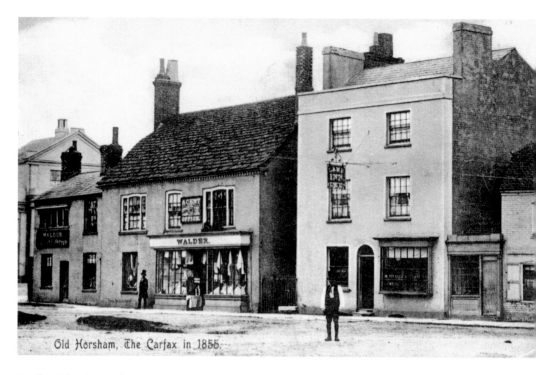

Old Horsham, The Carfax in 1855.

Carfax island, south-west corner

Another of Thomas Honywood's photographs, published as postcards by his son in the early 1900s, shows a public house called the Lamb Inn, and Samuel Walder's drapers shop on the south-west side of the Carfax island. The buildings remain little changed, but the tiny shop of 'Cobbler Will' next to the Lamb has disappeared. Henry Burstow described the gnome-like appearance of this Waterloo veteran and told a story about a firework thrown into his shop in his *Reminiscences of Horsham*.

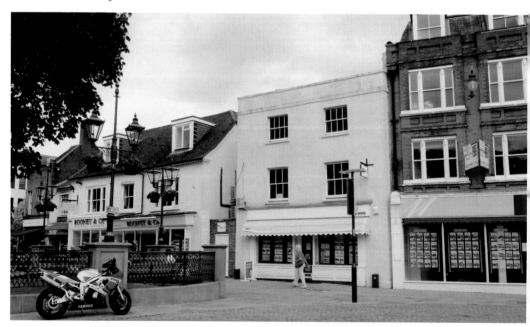

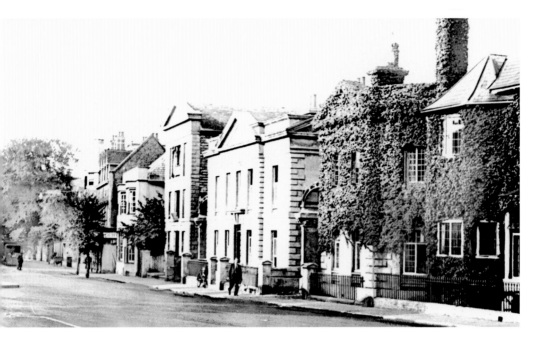

Carfax, west side

When this photograph of the west side of the Carfax was taken in 1933, the ivy-covered house was the home of Councillor Bernard Lintott, Chairman of Horsham Urban District Council on three occasions in the 1920s and 1930s. The adjoining building housed the offices and bacon factory of the Lintott wholesale grocery business, one of the main enterprises in the town at that time. Sterling Buildings, containing a row of shops, has been built in their place in similar Neo-Classical-style.

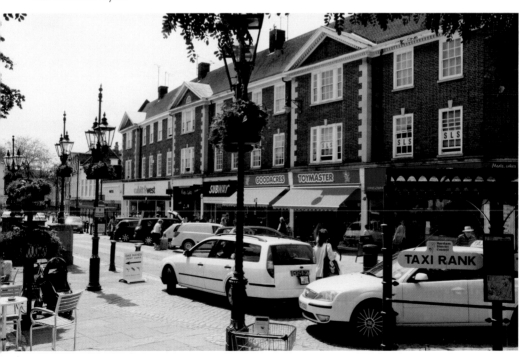

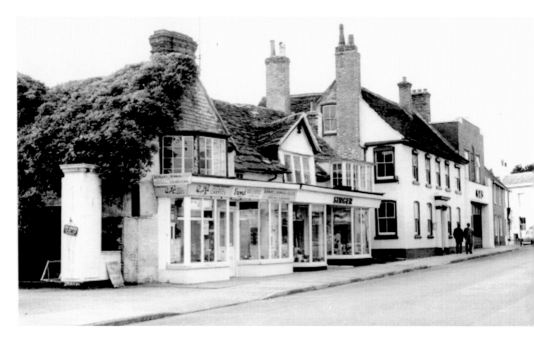

Carfax/London Road corner

Bornes, an ancient burgage house converted into shops when photographed in the 1960s, was controversially demolished in 1971 to make way for the Swan Walk shopping centre. Next door was Cotchings, a lawyer's office previously owned by Pilfold Medwin who, with his father, played an important part in Horsham affairs in the nineteenth century. This part of London Road is now pedestrianised and called Medwin Walk, and the Medwin papers, of great historical importance, are in the care of Horsham Museum.

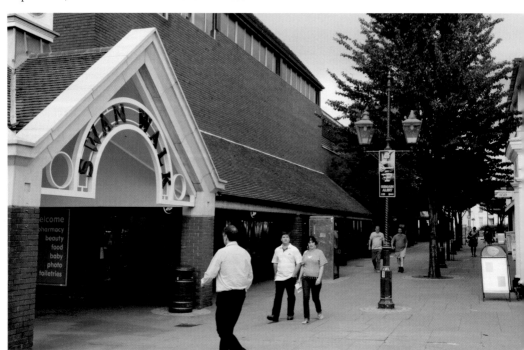

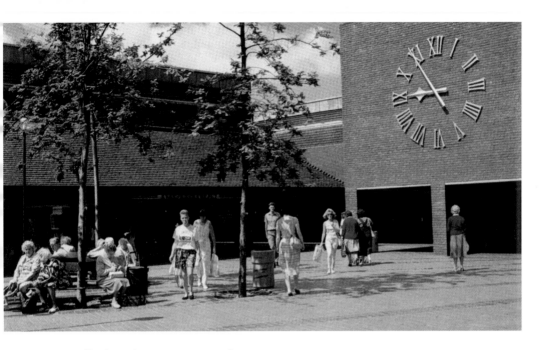

Swan Walk shopping centre — Carfax entrance

The Swan Walk shopping centre has undergone considerable change since it was first built in the 1970s. There was a giant clock at the original entrance and it was open to the skies. The centre was extended and roofed over in 1989 in a major refurbishment. The more recent view shows the redesigned entrance at Christmas time, when the illuminated tree catches the eye of a child as the short winter afternoon draws in.

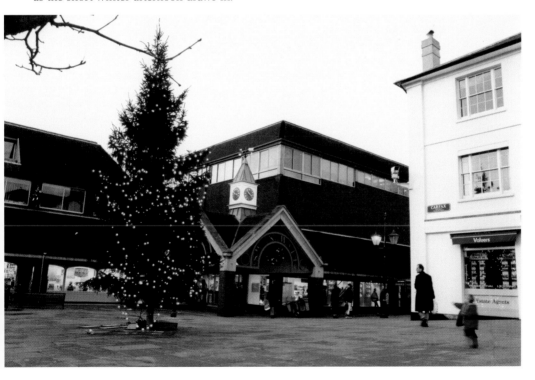

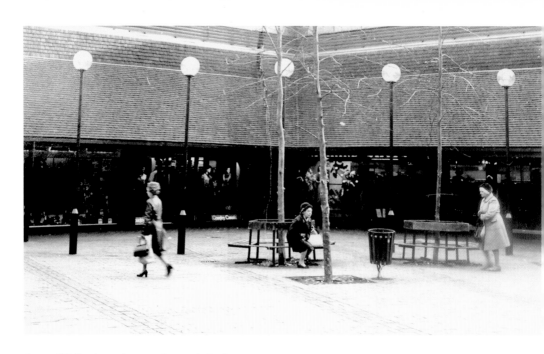

Swan Walk shopping centre — interior

Both photographs show the centre of Swan Walk, where the two main aisles from the Carfax and West Street meet. The Swan Hotel, after which it is named, stood by the West Street entrance. In the earlier photograph a few lamps and trees with surrounding benches were the only furnishings. Now this area houses Lorne McKean's magnificent swan sculpture, unveiled in November 1979. More recently a coffee and muffin bar has become an additional feature.

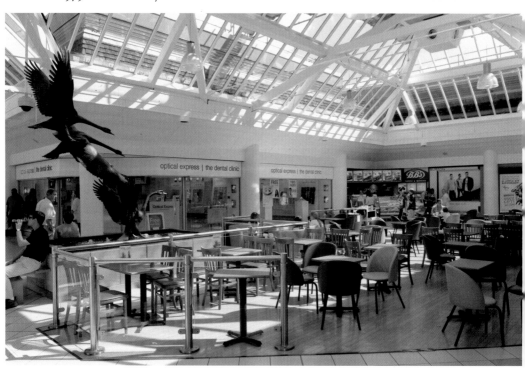

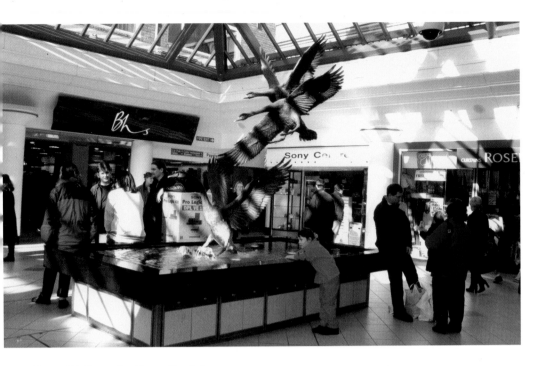

Swan Walk — the Swan Sculpture

The earlier photograph of this bronze sculpture, with the swans landing in rippling water, shows it when it stood alone in the central space. After a further refurbishment of the shopping centre, when the café was added and the glazing bars repainted, an attempt to move the swans elsewhere provoked outrage and a local newspaper campaign. This iconic sculpture has now been brought back to its former site, and its water-filled base restored, by public demand.

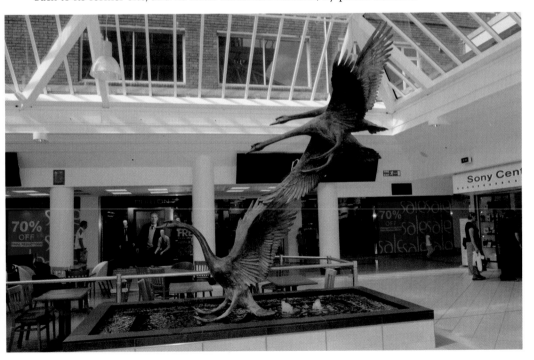

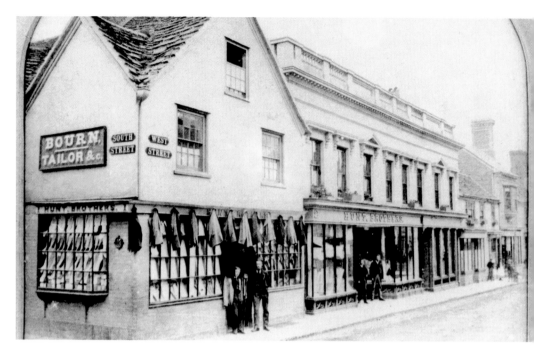

West Street/Carfax corner

The corner of West Street and South Street, facing the Carfax, has always been at the hub of
the town's activity and has undergone several changes in the past century. The original corner
building was known as 'The Old Crown or Somersett's' and it was probably an inn at some stage
in its history. It was rebuilt in Neo-Classical-style in around 1900 to match the Hunt brothers
building next door, with a pepperpot tower and large display windows.

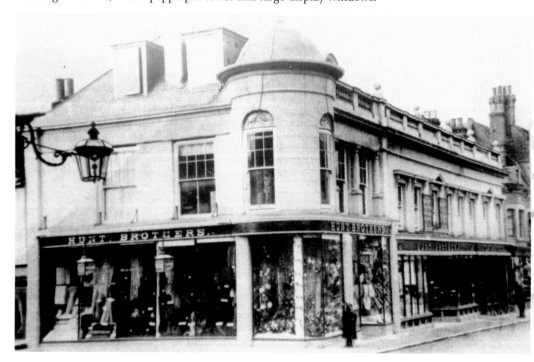

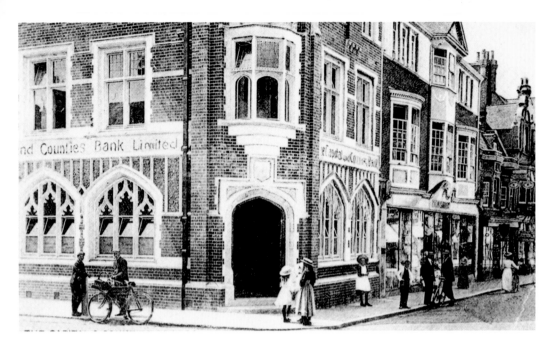

West Street/Carfax corner

A second rebuilding took place about 1912, when the Capital and Counties Bank moved into the new Gothic-style corner building, while Hunt Brothers, a high-class draper's shop, was rebuilt with an Italian Renaissance façade and an extra storey. Today the corner building remains as a bank and extends into the adjoining building. Most of the shops in West Street are now branches of national chain stores, replicated in high streets throughout the country, rather than independent local businesses.

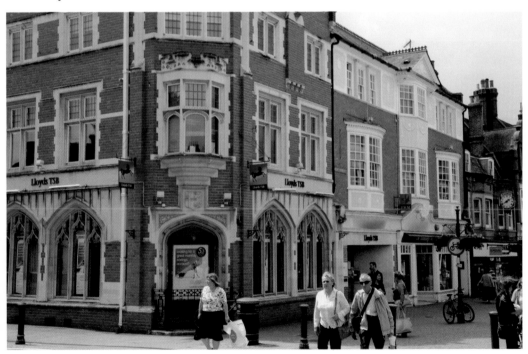

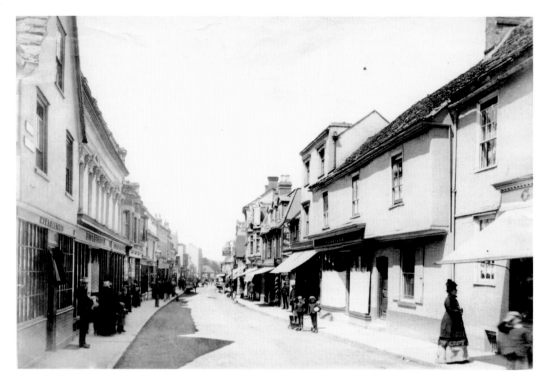

West Street looking west from the Carfax

In the earlier photograph, taken in the 1880s, many older buildings remain in West Street. In the later photograph Jury Cramp's well-known spectacles sign can be seen on the recently-built Clerkenwell House next to Hunts, and a new tall building with stepped gables can be seen beyond that. Timothy Whites was opened in 1906 and Rice's cycle shop, on the right, suffered a serious fire in 1909, so the later photograph can be dated to about 1908.

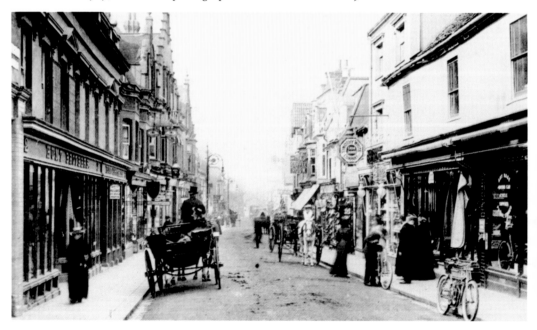

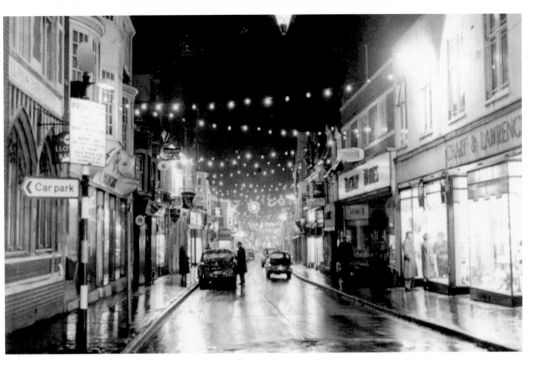

West Street looking west from the Carfax

Roger Baker photographed the Christmas decorations in West Street on a wet night in the 1960s. The sign in the foreground shows that it was now a one-way street, but long established shops like Hunt Brothers, Timothy Whites and Chart and Lawrence remained in place. All these shops have now disappeared, but the pedestrianised West Street of today, which has seen so many changes in the last century, still remains as the town's principal shopping street.

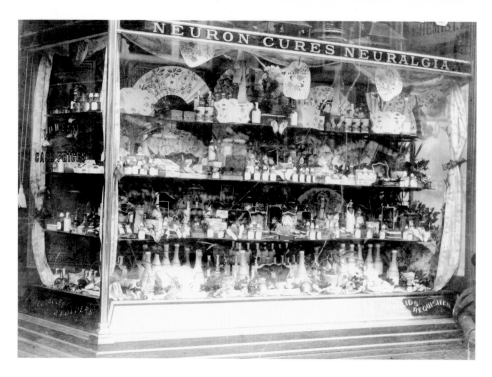

No. 5 West Street

The crowded shop window of Brassingtons the chemist, where bottles of pills jostled with Japanese fans and a huge variety of other objects for attention, was clearly a place for looking *in*. Brassingtons was an enterprising business that produced its own local street directory for some years in the early 1900s. Today the seating arrangements in the Starbucks coffee shop make this same window a place for looking *out* at whatever is going on outside!

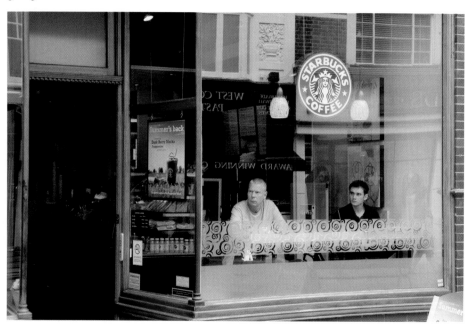

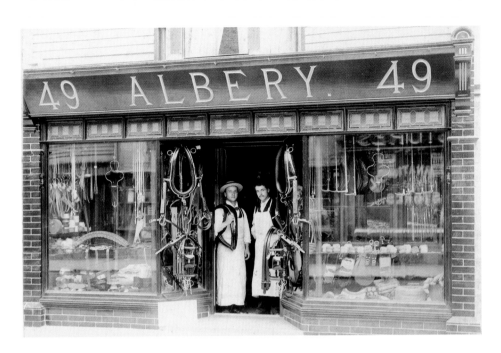

No. 49 West Street

The young William Albery, seen on the left in his shop doorway in about 1890, inherited the saddler's business started by his grandfather George Albery in 1810. William became the president of the Master Saddler's Federation but is better known now as a local historian and collector. He was instrumental in finding a permanent home for Horsham Museum, and his renowned saddlery collection can still be seen there in a re-creation of his old shop on the ground floor.

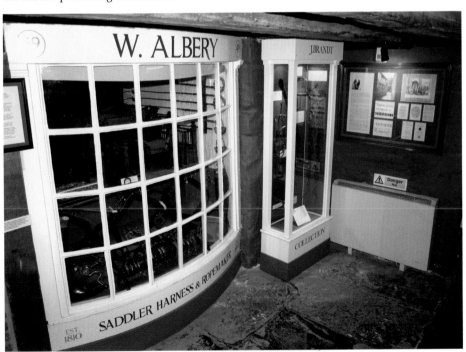

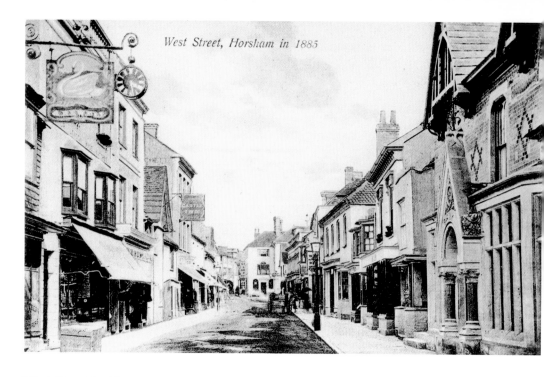

West Street, Horsham in 1885

West Street looking east

The postcard of West Street in 1885 shows the signboard of the original Swan Inn on the far left, before it was rebuilt. The sign of the Castle Inn can also be seen and Henty's Bank building, on the far right. The coloured postcard from the 1930s shows the rebuilt Swan Hotel on the left and the Russell shoe shop on the right (formerly The Golden Boot). The Russell family also had a grocery business in West Street.

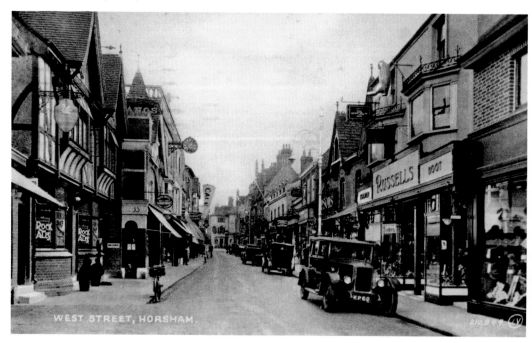

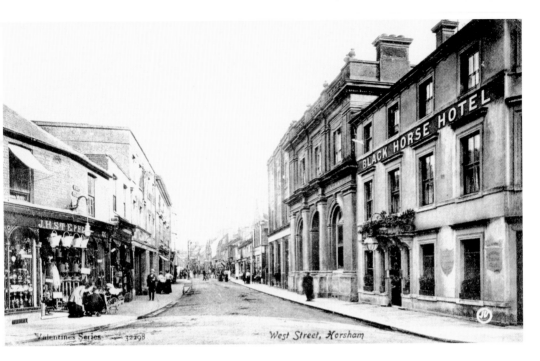

West Street from Black Horse Corner, now Lynd Cross, looking east

The Black Horse Hotel stood next door to the Corn Exchange, built by the Horsham architect Edward Burstow in 1886, at the junction of West Street with Springfield Road and the Bishopric. This area was rebuilt and eventually made into a large public space containing a water garden after through traffic was removed in 1994. In the centre stands the Shelley fountain 'Rising Universe', designed by Angela Conner, which has provoked mixed reactions ever since it was unveiled in 1996.

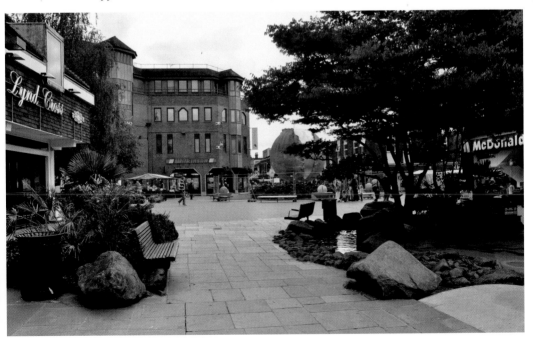

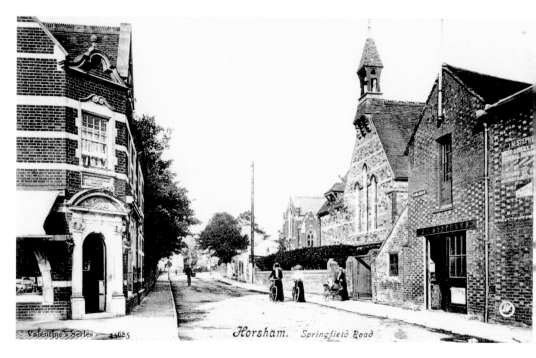

Lynd Cross, looking north up Springfield Road

In the earlier photograph, St John's Catholic church and the Congregational chapel can be seen on the eastern side of Springfield Road and the Seagrave bakery on the Bishopric corner. Now St John's church has been rebuilt on the opposite side of the road, and the Lynd Cross public house has been built on the corner site as part of the new public space around the Shelley fountain. (Lynd Cross was the medieval name of this area.)

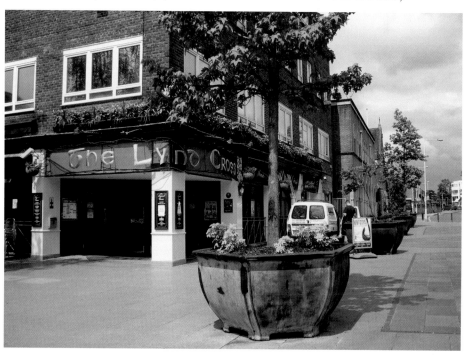

St John's Church, Springfield Road

The modern photograph shows St John's church and its new presbytery building in the quiet cul-de-sac that this part of Springfield Road has become. In the 1951 photograph, St John's church was seen from the west end of Albion Road, a narrow street which ran parallel to Albion Terrace between the Carfax and Springfield Road. Albion Road and Albion Terrace disappeared with the building of the Swan Walk shopping centre, and Springfield Road was cut through by Albion Way.

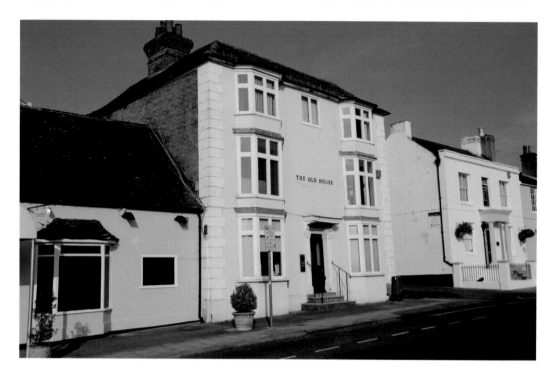

London Road, The Old House

Some of the old private houses in London Road still survive, with many personal associations. The Old House was the home of Major Middleton, who started the Blue Flash Cinema Company to help ex-soldiers find work in the 1920s. In 1871, William Pirie's widow and children lived there and it was called Gordon House. Later it became the home of Dr Francis Kinneir who is seen showing off his new car outside the house, then smothered with ivy, in the early 1900s.

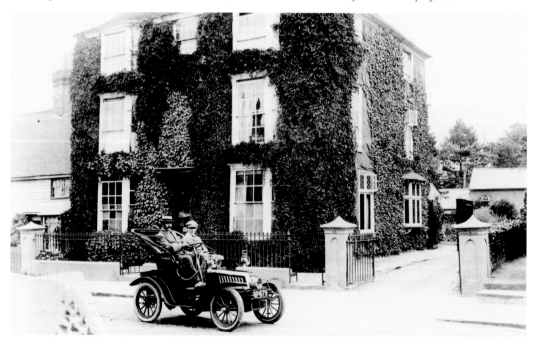

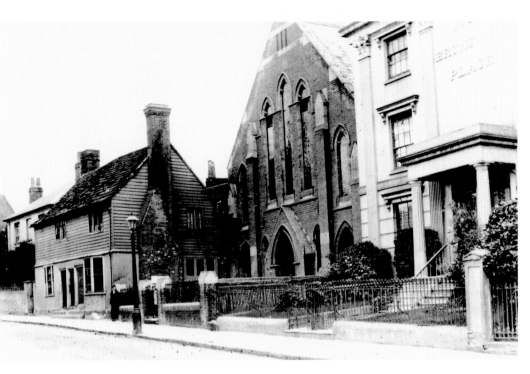

London Road, Methodist Church, Brunswick Place and Sussex Place

In 1831 Miss Catherine Ireland bought a piece of land that had been the site of the House of Correction until the 1770s. She gave part of it to the Methodist Chapel in 1832, and built her own house, Brunswick Place, next door. Shortly afterwards the adjoining terrace, Sussex Place, was built by Benjamin Fox, of Chestnut Lodge, to provide an income for the lifelong support of his mentally handicapped daughter, Katherine, who was cared for by a devoted cousin.

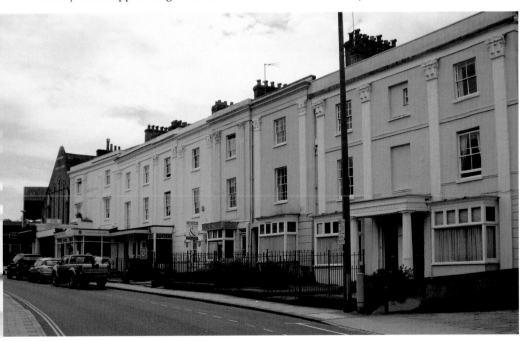

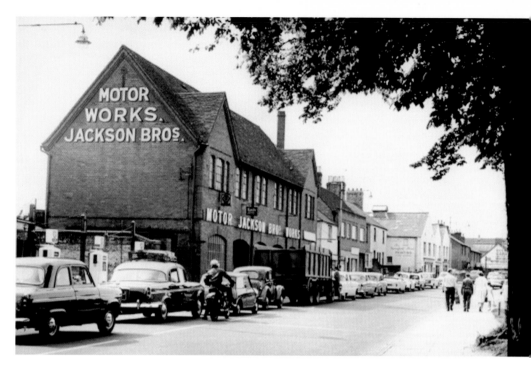

Springfield Road between North Parade and Albion Way

In the earlier photograph, taken in the 1960s, Jackson's motor works, the Springfield Press (formerly the malthouses belonging to the notorious Allen brothers who tried to cheat the excise with their hidden vats), and a row of old cottages can be seen, looking from North Parade. Now the modern view from Albion Way shows the new YMCA on the right and various other new buildings along this same stretch of road, which has been completely redeveloped.

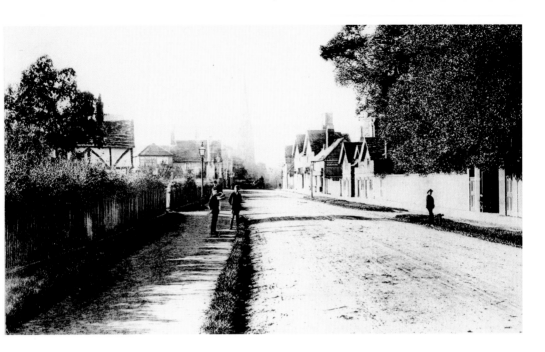

North Street, looking north

In the earlier photograph, the old burgage house known as Perry's Place can be seen on the left before being moved in 1912 to Mannings Heath where it was rebuilt. It serves today as the clubhouse for the golf course. Today the new glass front of the Capital Arts Centre (formerly the Ritz and then the ABC Cinema) can be seen on the left, with the Royal Sun Alliance buildings in the centre. Parkside House off Chart Way looms up on the right.

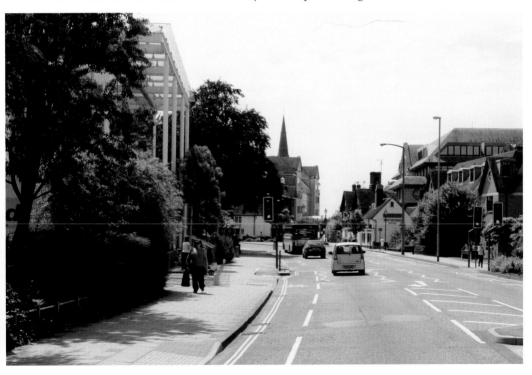

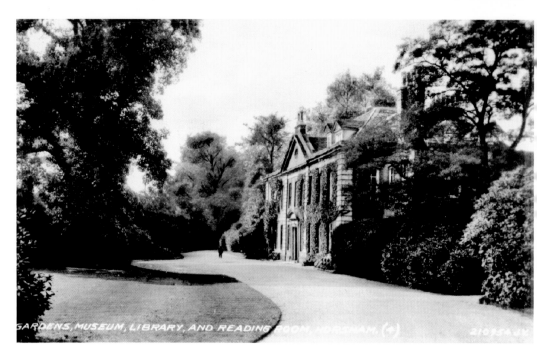

Park House from North Street

Park House was built in the early eighteenth century by John Wicker, a wealthy brewer, and was later the home of the Hurst family. The earlier photograph shows the house in the 1930s, after it had been bought by Horsham Urban District Council for their headquarters. Two rooms had been set aside to display the Horsham Museum collections after a political campaign by William Albery. Since 1974 it has housed the chairman's and administrative offices of Horsham District Council.

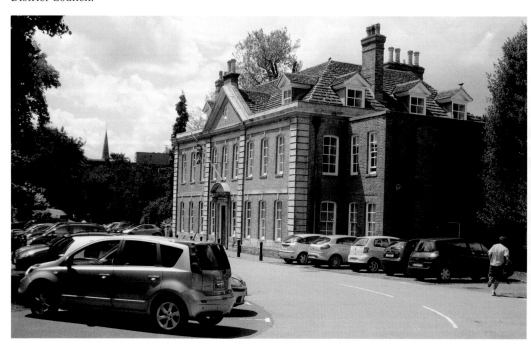

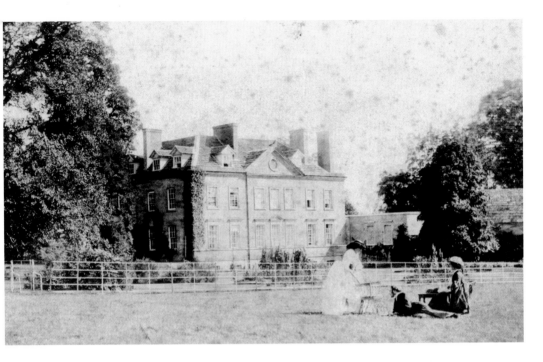

Park House, Garden Front

This very early photograph shows Park House in the 1850s, when Robert Henry Hurst was in financial difficulties and it was let out to tenants. The people in the foreground have not been identified. The modern photograph shows the garden front overlooking Horsham Park, where an award-winning garden was opened in 1991, specially created for the blind and disabled, by Sun Alliance and Horsham District Council. The sundial was designed by a local artist, John Skelton.

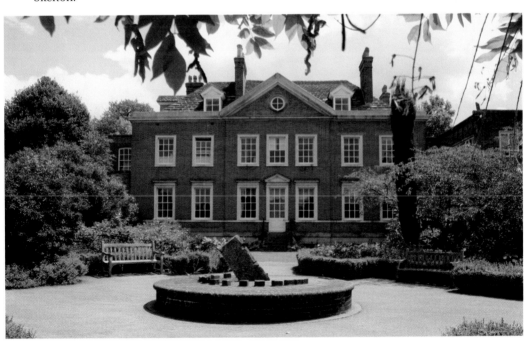

North Chapel, North Street

North Chapel was owned in 1545 by a religious fraternity, and was probably used as an almshouse for poor people. In 1760 it became the home of John Smart, the miller, and his wife Elizabeth. Elizabeth Smart's diary for that year has recently come to light and gives interesting details of her daily life and household accounts — she brewed beer and took in lodgers. The photographs show that North Chapel has changed very little in appearance during the last century.

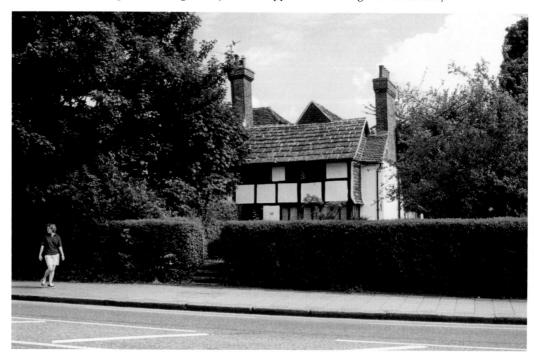

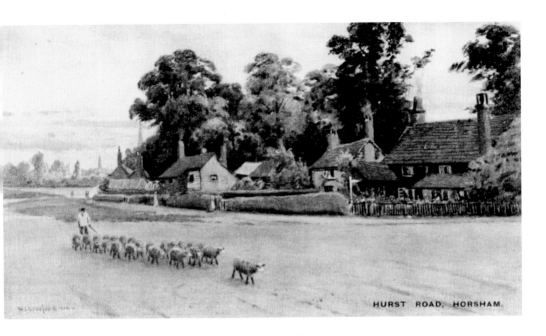

HURST ROAD, HORSHAM.

Old Cottages opposite the Railway Station, North Street

The old cottages opposite the station were painted by William Smart Russell, a grocer in West Street and an amateur artist whose local watercolours became popular postcards in the 1920s. Today it can be seen that the cottage on the right, called Harvest House, has survived unchanged, while some of the others have been incorporated into a residential development called Parkside Mews, which has retained much of the 'village green' character of this remnant of old Horsham.

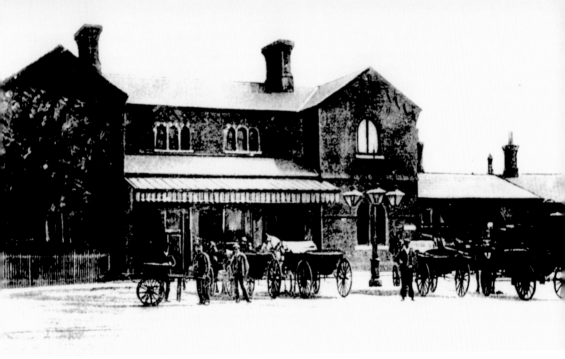

Horsham Railway Station, North Street

The railway came to Horsham in 1848, and the first railway station was built on the west side of North Street. By the 1860s, Horsham had become an important railway hub, with lines radiating to London via Dorking and Three Bridges, to Brighton via Shoreham, and to Portsmouth and Guildford. The second station, shown in the earlier photograph, was built in 1859 in its present position, while the modern station was built in the 1930s when the line was electrified.

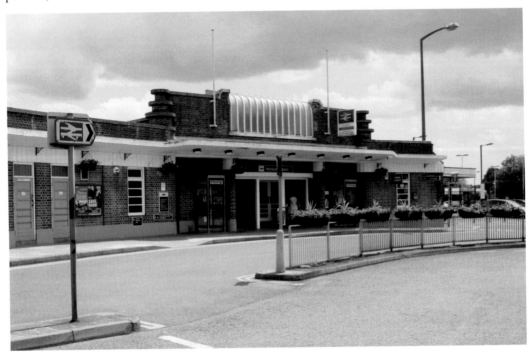

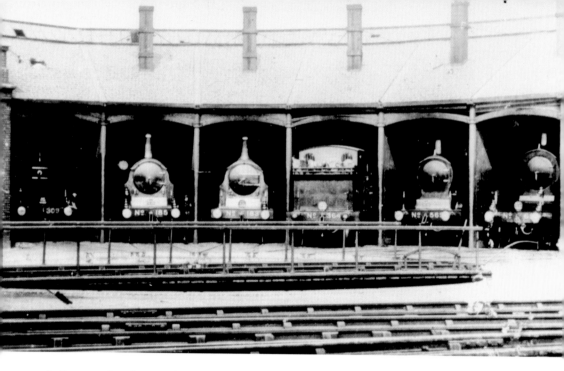

Railway trains then and now

The earlier photograph, taken on a quiet Sunday in the early 1900s, shows Horsham's impressive roundhouse with its turntable and several engines parked in their sheds (looking remarkably like Thomas the Tank Engine!) Horsham was then part of the London, Brighton and South Coast Railway network. Today the roundhouse has disappeared and the trains are parked beside the platforms, as seen from the railway bridge. The line to Guildford was closed in 1965 as part of Dr Beeching's cuts.

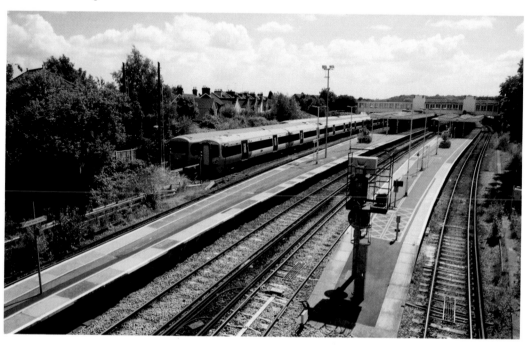

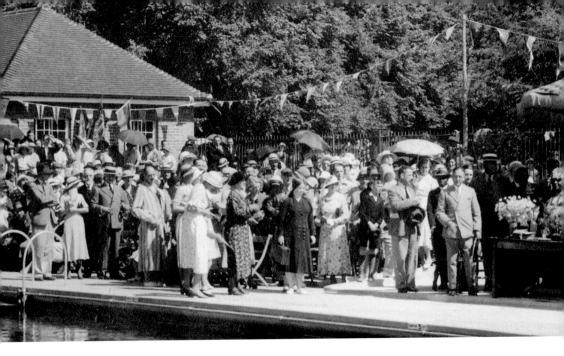

Public swimming pools in Horsham Park

The opening of the first public swimming pool in Horsham Park took place on 7 July 1934, performed by a visiting dignitary from the Gold Coast, Sir Ofori Atta, KBE. He can be seen on the far right of the earlier photograph, under a large umbrella. The building of this open-air pool provided work for unemployed men in the 1930s Depression. The 'Pavilions in the Park', a glass-fronted 'state of the art' swimming and athletics centre that cost £15.4 million, was opened in November 2002.

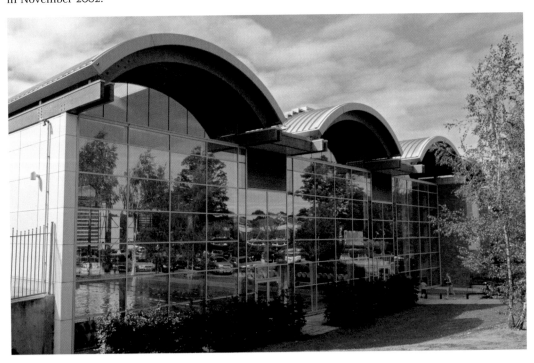

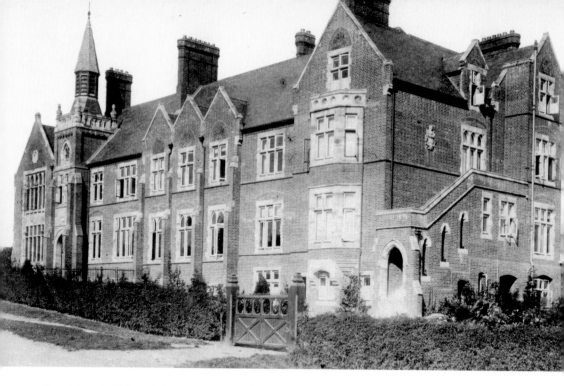

Hurst Road, Collyer's Grammar School/Sixth Form College

Collyer's School, formerly in Denne Road, was rebuilt in 1893 on this site in Hurst Road and re-established as a grammar school under the headmastership of the Revd G. A. Thompson. It operated very successfully for the next eighty years but, after the national reorganisation of secondary education along comprehensive lines, it became a sixth form college in 1976. It has succeeded in maintaining high levels of achievement and honours its founder's precept that 'none be refused likely to learn'.

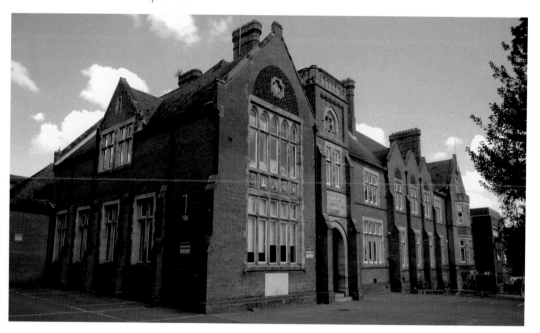

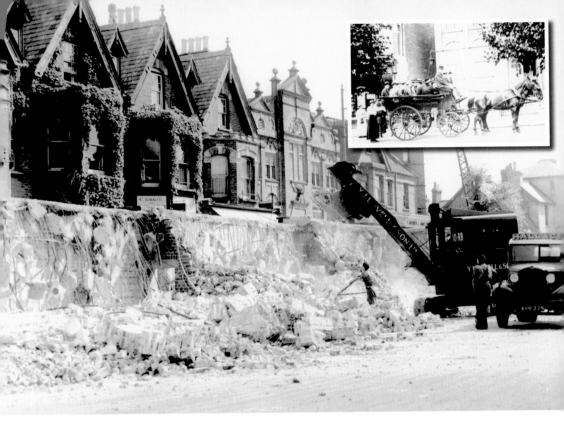

East Street, Primitive Methodist Chapel/Christian Life Centre

In the earlier photograph, which shows the demolition of the public air-raid shelters in East Street after the end of the Second World War in 1945, the former Primitive Methodist chapel can be seen to the right of the terraced houses. The inset shows Ansell's 'wagonette' with a 'sisterhood outing', outside the chapel in the early 1900s. Now it stands on the corner of Parkway, the link between Albion Way and East Street, and has become the Christian Life Centre.

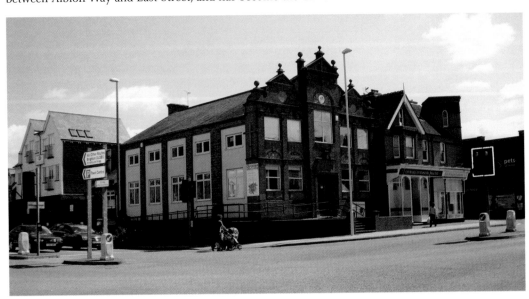

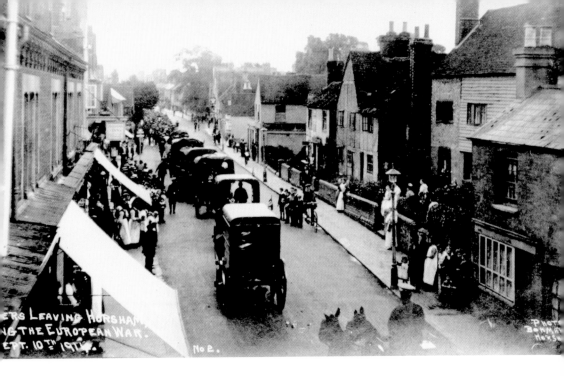

Queen Street from the railway bridge

The earlier photograph shows soldiers leaving Horsham in trucks on 10 September 1914, very early in the First World War, when neither they nor the people watching them leave would have had any idea of what awaited them. The postcard was produced by the Bon Marché photographic studio in Queen Street, very near to where the picture was taken. The modern photograph shows that most of the buildings on the south side of the street have now been rebuilt.

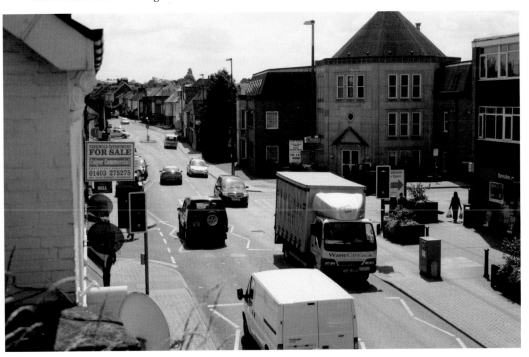

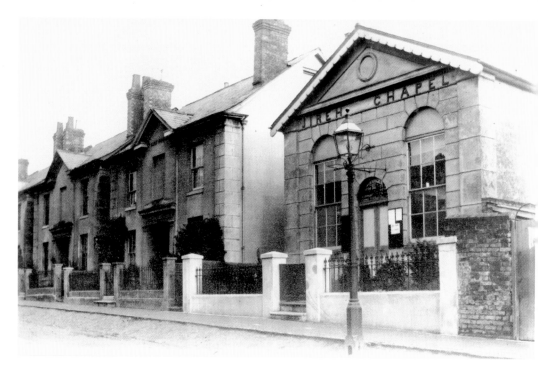

Park Terrace East, Jireh Chapel/Mosque

The Jireh Strict Baptist chapel, built in Park Terrace East, was opened in 1857 and could seat 150 people. After the congregation dispersed about forty years ago it became a beauty salon but is now once again a place of worship, as a mosque for Horsham's small Muslim community. Park Terrace East was built on the site of the former 'model' gaol, pulled down in 1845. It was the first gaol in the world to have individual cells for prisoners.

Brighton Road Baptist Church

One of the most recent buildings in Horsham to be rebuilt is the Brighton Road Baptist church, seen here as a Victorian red-brick building in 2000 and as a very new and modern-style church in 2009. The curve of its roof seems to echo the curved fronts of the old cottages beyond it, which are built in the distinctive style associated with the Horsham builder John Morth, who built a similar cottage in Morth Gardens for his daughter.

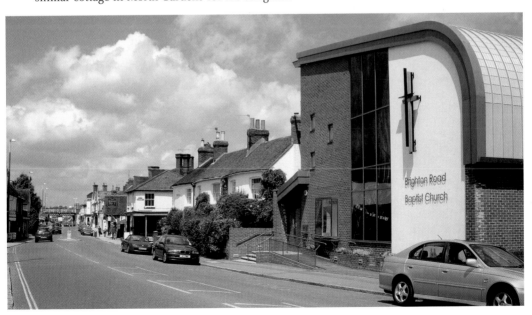

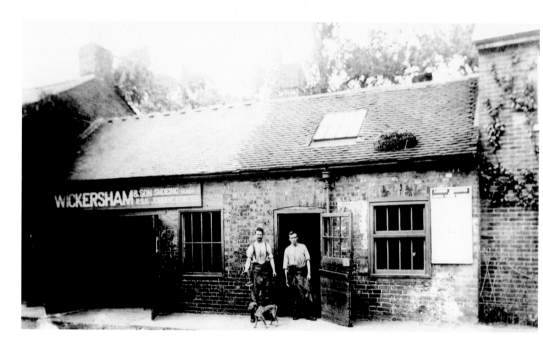

Wickersham Forge/Park Surgery

Wickersham Forge was one of the several smithies in Horsham in the nineteenth century, when horse-drawn traffic was the norm. Many of these were later converted to motor garages, but after the rest of Wickersham Road disappeared under Albion Way, Park Surgery, a large medical practice, was built on this site. Recently rebuilt, it now has its own pharmacy and is linked by a subway to Medwin Walk.

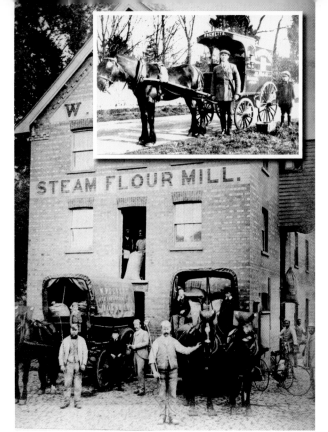

Prewett's Mill, Worthing Road
By 1891, William Prewett owned the town mill and the steam mill in Worthing Road that had been built in 1861. His sons, Fred and Charles, continued in business until the 1970s and had their own bakery in West Street. (The inset photograph shows one of Prewett's horse-drawn delivery vans in the 1920s, with its driver, Ralph Tarrant, in North Parade). Prewett's mill was the last to produce stone-ground flour in Horsham, but was converted into offices in 1983.

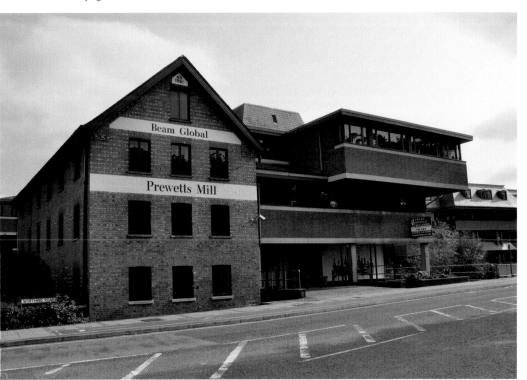

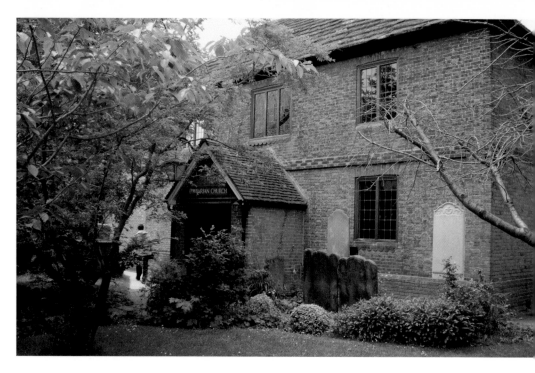

The old Baptist Chapel, Worthing Road

The Baptist chapel was built in 1721 and Matthew Caffyn was its first minister. It was the first Non-conformist chapel to be built in Horsham. The Free Christian Church took over the chapel in the late nineteenth century, and several of their members played an important part in setting up the Horsham Museum Society in 1893. Now this historic building is the home of the Unitarian Church, but its earlier history is not forgotten.

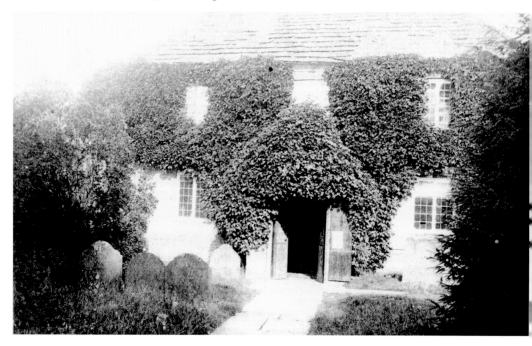

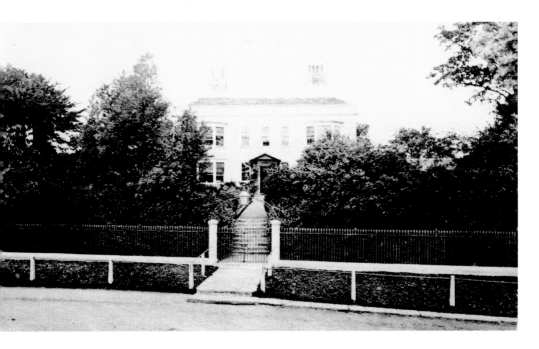

Tanbridge House, Worthing Road

The earlier photograph shows the original Tanbridge House, which was the home of the Ellis family in the eighteenth century. Thomas Oliver, a railway contractor, leased it in the 1850s and was eventually able to buy it and build a much larger mansion with a finely decorated interior in 1887. After his death in 1921, it became the Horsham High School for Girls, but it is now divided into apartments as part of a large residential development in the surrounding grounds.

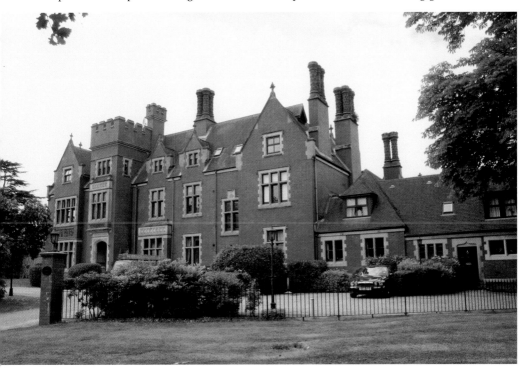

Pict's Hill/Tower Hill corner

The earlier view of the junction of the road through Tower Hill with the road down Pict's Hill shows the Fox and Hounds public house on the corner. Today the old pub still remains, but it is now called The Boar's Head. A paved pathway known as 'The Lover's Lane' lies behind the pub, which was an early route to Stammerham, where there were rich quarries of Horsham stone. These made their owners, the Michells, wealthy local landowners in the seventeenth century.

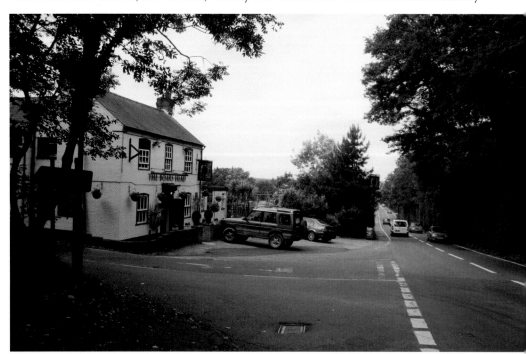

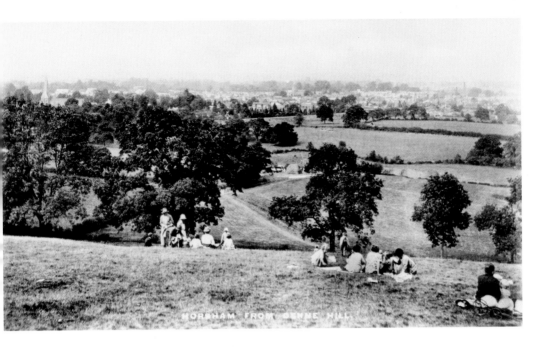

View over Horsham from Denne Hill

The view over Horsham from Denne Hill has been a popular subject for artists and photographers since the eighteenth century, and it has long been a favourite place for Horsham people to go on a fine summer's day. Groups of people are seen picnicking there in the 1930s. St Mary's church spire remains as a prominent landmark, but in the recent photograph the cricket field and the Royal Sun Alliance buildings can also be clearly seen.

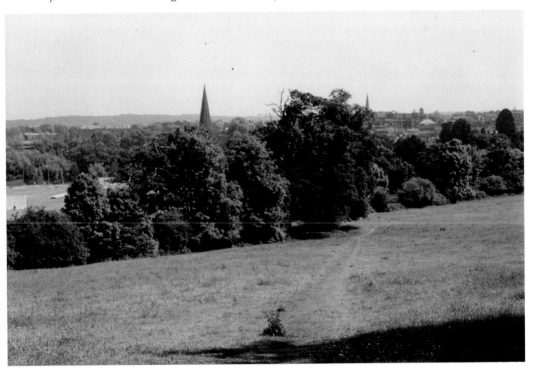

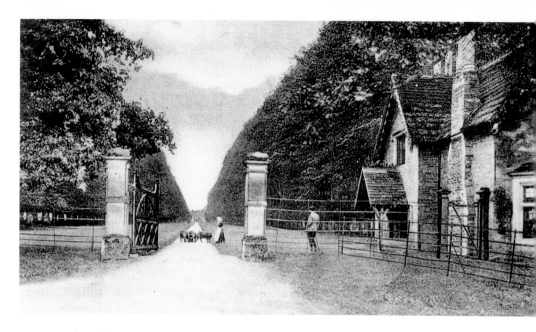

Denne Park Lodge and Avenue

The great avenue of 110 lime trees, planted in four rows along the half-mile drive from the Denne Lodge gate to Denne House in the distance, is one of the most impressive landscape features in Horsham. It dates from the eighteenth century and suffered considerable damage in the 1987 hurricane but has now been restored to its former beauty. The Victorian lodge house with its decorative bargeboards makes an attractive subject for the modern photographer.

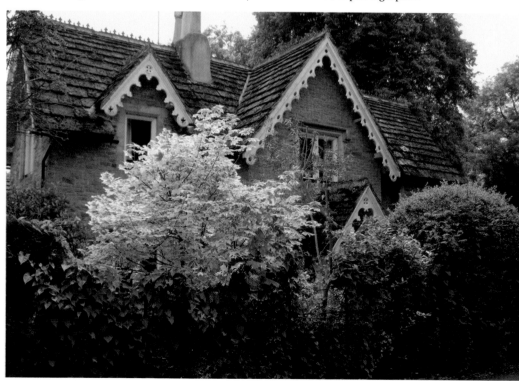

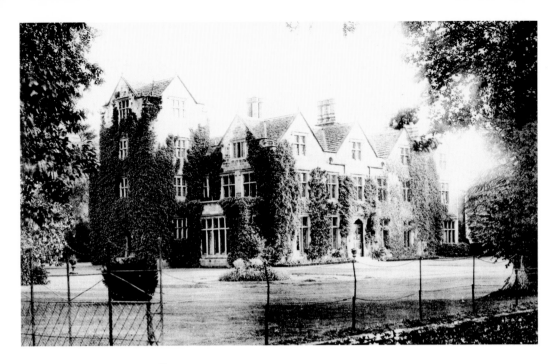

Denne House, west front

Denne House, built about 1605 by Sir Thomas Eversfield, is the oldest of Horsham's historic houses to survive much as originally built until the present day. Its west front was rebuilt in Italian Renaissance style in the eighteenth century but it was restored to its original style in the 1870s when the house was extended. It was converted into twelve apartments during the 1950s in one of the first such schemes in Horsham.

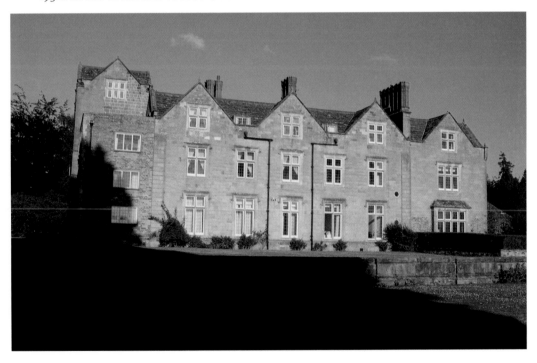

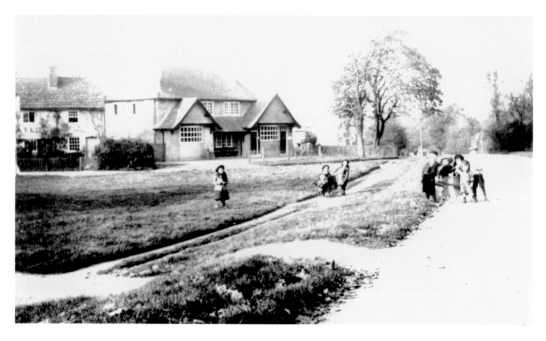

The Dog and Bacon Inn, Horsham Common

The original inn was the weather-boarded cottage on the left, built as a stage on the turnpike road from London. John Smart, the miller, was the landlord at the time of his death in 1772, but it was probably his wife, Elizabeth, who managed the inn as an additional source of income. The present public house on the right was built about 1905. The green in front of the buildings has a plaque marking it as the last remnant of Horsham Common.

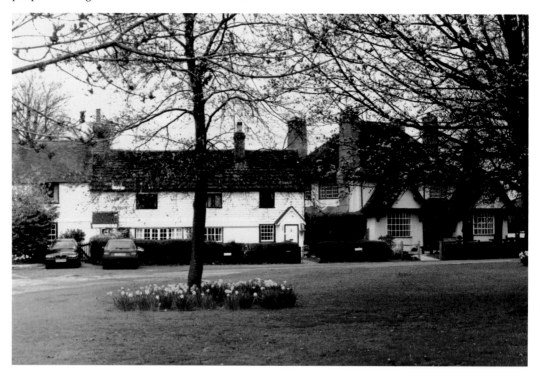

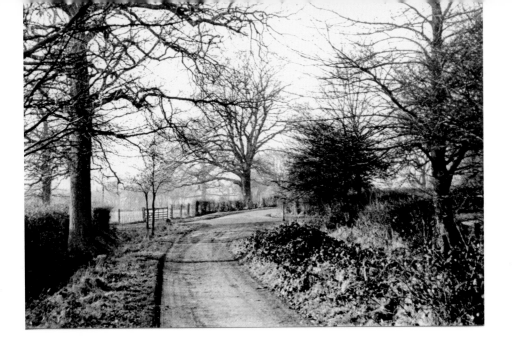

Trees on Horsham Common

The 1951 photograph of Compton's Lane and Depot Road, seen from Hamper's Lane, shows what this part of Horsham Common looked like before it was built over in the 1960s. Several of the great oak trees that marked the edge of the common can still be found in Compton's Brow Lane, here seen in autumnal splendour. The signpost points to a narrow footpath, marked on early maps and leading towards the forest pools, where leeches were collected for medicinal purposes.

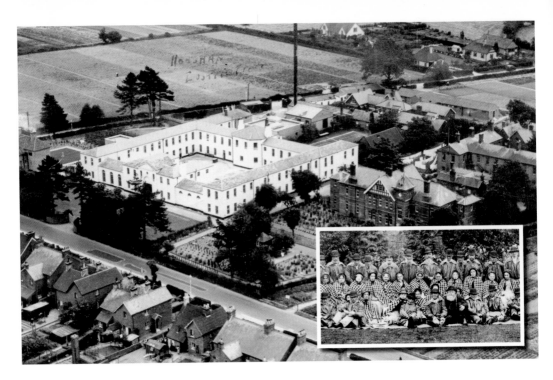

The old Union Workhouse, Crawley Road

An aerial photograph taken in the 1920s shows Horsham's Union Workhouse, built in 1838, which was the largest public institution in Horsham in the nineteenth century. (Inset is a photo of some of the workhouse inmates, probably taken in 1897.) As Horsham Institution, it provided poor relief for vagrants in the 1930s, but during the Second World War it became a base hospital for Canadian troops. Now the front part has been divided into flats and the courtyard rebuilt as houses.

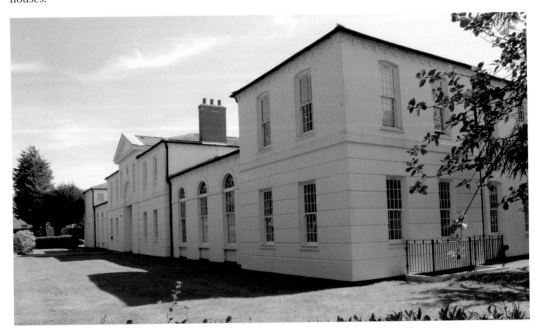

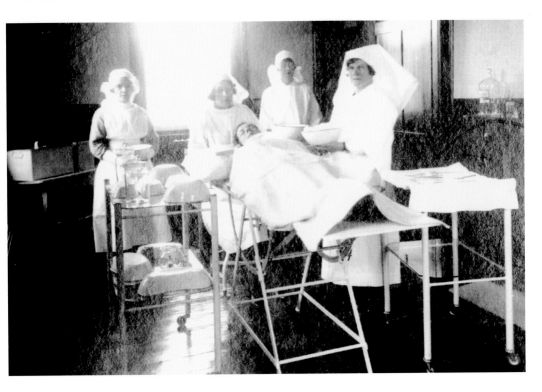

The old Workhouse Hospital

The workhouse infirmary, built in 1866, was one of the first in the country, and its facilities were made available to other patients, as Horsham did not have its own public hospital until 1892. The infirmary continued to operate as part of Horsham Institution, as seen here, before its wartime use by the Canadians. It then became the Forest Hospital, for patients with mental problems, until about 1990. It is now divided into flats and called St Leonard's.

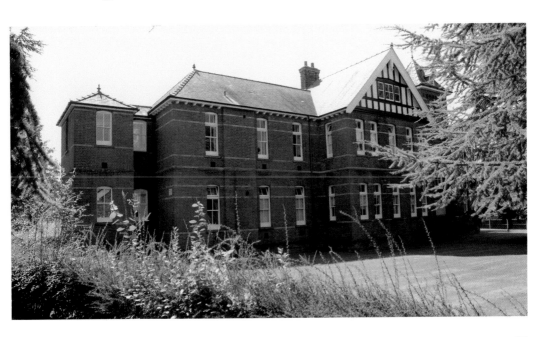

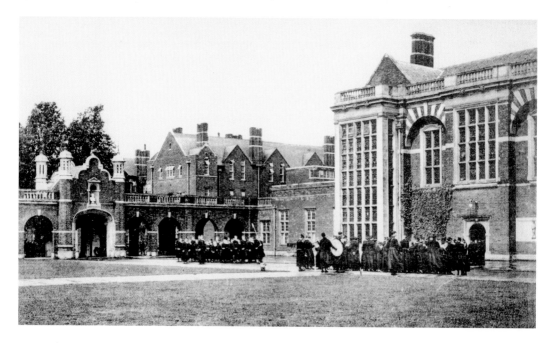

Christ's Hospital School, Stammerham, outside Horsham

The relocation of Christ's Hospital from the city of London to a large site outside Horsham, where the new school was built between the years 1897 to 1902, had a considerable impact on the town. It soon established itself as an important part of the community. The traditional ceremony in which the pupils assemble outside and march into the dining hall accompanied by their band remains unchanged, but nowadays it is watched with interest by a group of visitors.

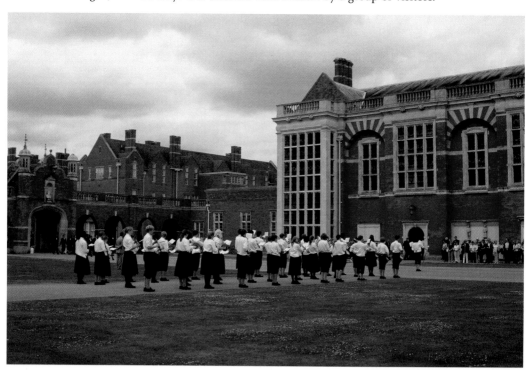

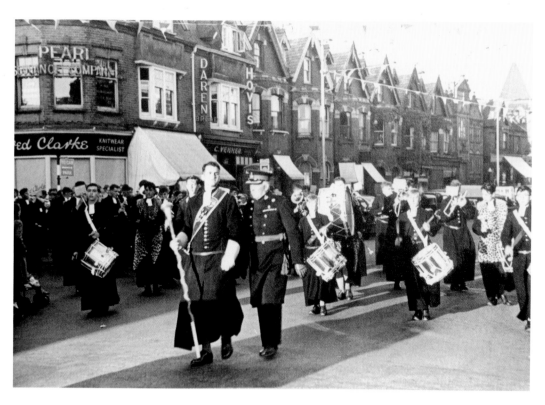

Christ's Hospital Marching Band

During the past century, the Christ's Hospital Marching Band has become an indispensable part of many of Horsham's celebrations. Here they are seen in the 1951 festival procession, in East Street, as part of the annual carnival held during Cricket Week. The recent photograph of the band shows one striking difference: the girls who were formerly at a separate school in Hertford rejoined the boys in 1985 and the school is once again co-educational, as it was when founded in 1552.

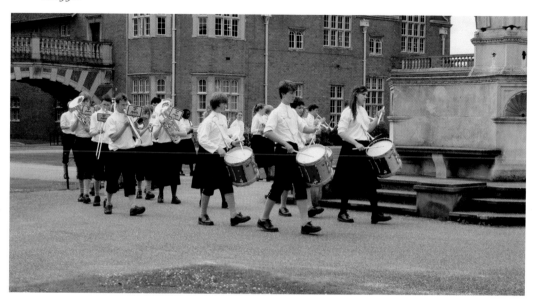

The Forum

These photographs of the final part of the redevelopment of the town centre cannot really be compared with any earlier street scenes, as the new public space called The Forum has been created out of what used to be the gardens behind the Manor House. The back of the Manor House can just be glimpsed in the top photograph, and the great weeping beech tree, planted in its garden many years ago, has been retained as a special feature.

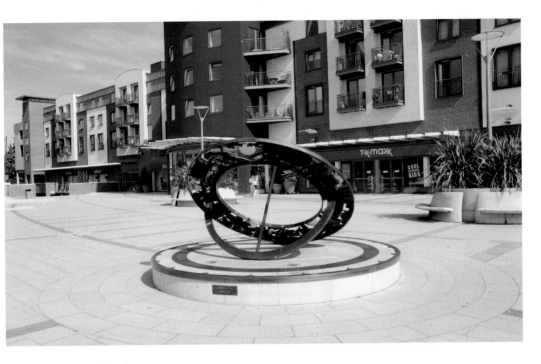

The Sundial in The Forum

In the centre of The Forum is the great bronze sundial designed by the sculptor Lorne McKean and her husband Edwin Russell to tell the history of Horsham District. It was unveiled by Her Majesty the Queen on 24 October 2003. At the base of the wheel can be seen the horses that gave Horsham its name, above the mythical dragon in St Leonard's Forest and one of the Wealden iron forges that brought prosperity to the town in the seventeenth century.

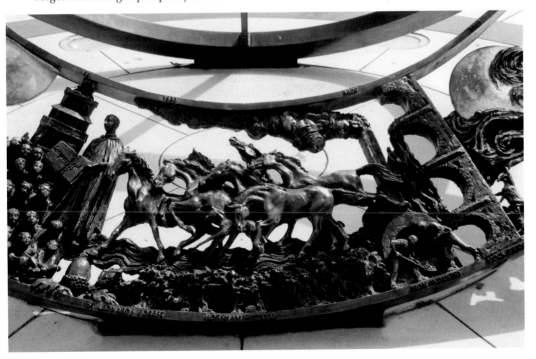

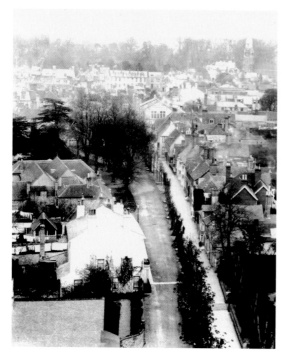

View northwards from St Mary's Church spire
A last look over Horsham from an unusual vantage point. This photograph of The Causeway was probably taken during repairs to the spire in about 1905 and shows domestic details, such as the washing lines behind the houses of the people living in The Causeway. The lime trees at the top of The Causeway had recently been replanted and are still small. The town hall, Richmond Terrace in the Carfax and St Mark's church in North Street can be seen in the distance.

Acknowledgements

To Jeremy Knight, Curator of Horsham Museum, for the use of photographs from the Museum's collections, with thanks to Jason Semmens, Julie Mitchell, Liz Harvey and Bill Matthews, for their help in locating, scanning and making them available.

To Roger Baker, ARPS, chairman of Horsham Photographic Society, Martin Woolger and Anne and Peter Kingham, many thanks for taking the new colour photographs for this book. Also to Roger Baker, ARPS, for allowing the use of some of his photographs taken during the 1960s, and to earlier members of the Horsham Photographic Society who took photographs of the town in 1951 and 2000.

To Alan Siney for the colour photograph of the Dog and Bacon Inn on page 88, and to Ray Luff for his photograph of the 1992 Remembrance Day on page 47. The photograph of St Mary's church on page 8 was taken by Edgar Bastard and donated to Horsham Museum after his death in 1960. The aerial photograph of Horsham Institution and Hospital on page 90 was taken by Pan-Aero pictures and a copy donated by Mr Ron Murrell to Horsham Museum. Colour photographs on pages 87 and 89 were taken by the author. We are indebted to Christ's Hospital School and Southern Railway for allowing the use of photographs taken at the school and the railway station.